PORT SUNLIGHT
AND ITS PEOPLE

Jo Birch

"To memories"
Kindest wishes
Jo Birch

AMBERLEY

One of Lord Leverhulme's bookplates.

Cover photographs by Paul Thompson, copyright Port Sunlight Village Trust.

First published 2018

Amberley Publishing
The Hill, Stroud
Gloucestershire, GL5 4EP

www.amberleybooks.com

British Library Cataloguing in Publication Data.
A catalogue record for this book is available from the British Library.

ISBN 978 1 4456 7368 4 (print)
ISBN 978 1 4456 7369 1 (ebook)

Origination by Amberley Publishing.
Printed in Great Britain.

'Port Sunlight is so fabulous it could be a film set,' observed my late sister, Julie, to whom this book is dedicated.

Victorian scrap. Sisters.

Contents

Acknowledgements

Luck! Meeting the right people at the right place at right time.

Occasionally we support someone without realising; a kind word or deed, an encouraging nod or a handwritten note: 'How exciting you are writing a book. I do hope all goes well with it.'

I am grateful to the following – some will know how they have assisted, others will be surprised to see their names here:

Matthew Bailey, National Portrait Gallery, London; Pam and Alan Carey; Holly and Jamie Dixon; Mark Edwards, Johnston Press, Midlands; Leslie and Tony Hardy-Smith; Angie, Chelsea and Peter Harris; Lord Leverhulme's great-granddaughter, Lady Jane Heber-Percy; Chris Holifield; Tom Hughes, Port Sunlight Museum; Stuart Irwin; Anni and Peter Johnson; Lord Digby Jones; Paul King; Andrew Lownie, Literary Agent (not mine but a generous one who pointed me in the right direction); Kath Lynch, Port Sunlight Museum; Joanne and Kevin Massey; Will Meredith, Wirral Archive Services; Debbie Milligan, Johnston Press, Midlands; National Museums, Liverpool; Colin Panter, Press Association; Paul Polman, Unilever; David Powell, D. C. Thomson & Co. Ltd; Pamela Runnacles, Unilever; Agata Rutkowska, Royal Collection; Angie Sen; Connor Stait, Amberley Publishing; Pam and Jim Steane; Val and Gordon Wilkinson; Sam and Craig Willetts.

Additionally, the author and publisher would like to thank the following people/organisations for permission to use copyright material in this book:

Chapter 1: Description of 21 Upper Dicconson Street © Historic England [2017]. The National Heritage List Text Entry contained in this material was obtained on 3 August 2017. The most publicly up to date National Heritage List Text Entries can be obtained from http://www.historicengland.org.uk/listing/the-list/.

Chapter 2: A Symphony in Soap. Newspaper transcript © The British Library Board. All rights reserved. With thanks to the British Newspaper Archive (www.britishnewspaperarchive.co.uk).

Chapter 4: Happy Days Fifty Years Ago. Transcript © D. C. Thomson & Co. Ltd. With thanks to David Powell and the *Evening Telegraph*. Reproduced with kind permission of the British Newspaper Archive.

The O. P. Club. Newspaper transcript © The British Library Board. All rights reserved. With thanks to the British Newspaper Archive.

Mark Edwards from Johnston Press has shown enormous generosity in allowing me to use articles from their various newspapers.

Lord Leverhulme's Good Nature. Transcript © Johnston Press. With thanks to the *Hartlepool Northern Daily Mail*. Reproduced with kind permission of The British Newspaper Archive.

Blunt Speech. Transcript © Johnston Press. With thanks to *The Portsmouth News*. Reproduced with kind permission of the British Newspaper Archive.

Chapter 5: Lord Leverhulme and Samuel Smiles. Transcript © Johnston Press. With thanks to *The Portsmouth News*. Reproduced with kind permission of The British Newspaper Archive.

Chapter 10: Come and Live With Us. Transcript © Johnston Press. With thanks to *The Lancashire Post*. Reproduced with kind permission of The British Newspaper Archive.

Chapter 12: Lord Leverhulme's Joke about Weddings. Transcript © Trinity Mirror. With thanks to Simon Flavin and the *Western Gazette*. Reproduced with kind permission of The British Newspaper Archive.

Chapter 15: A Grocer's Assistant with £10,000,000. Transcript © Trinity Mirror. With thanks to the *Wells Journal*. Reproduced with kind permission of The British Newspaper Archive.

Lord Leverhulme's Long Day. Transcript © Trinity Mirror. With thanks to the Tamworth *Herald*. Reproduced with kind permission of The British Newspaper Archive.

Chapter 18: Lord Leverhulme Accurately Predicts the Future. Transcript © Trinity Mirror. With thanks to the *Yorkshire Post and Leeds Intelligencer*. Reproduced with kind permission of The British Newspaper Archive.

All items featured in this book are from the author's personal collection, apart from Alan Carey's booklet 'My Visit to Liverpool'.

Unilever PLC have kindly granted permission to reproduce the Lever Brothers memorabilia; where copyright exists, it belongs to Unilever PLC.

Every attempt has been made to seek permission for copyright material used in this book. However, if we have inadvertently used copyright material without permission/acknowledgement we apologise and we will make the necessary correction at the first opportunity.

I am indebted to the whole team at Amberley for taking a chance on me and, if you have stayed with me this far, I thank you, the reader, for you are the reason we write.

A Special Acknowledgement

There are no ghosts at Thornton Manor, Lord Leverhulme's home on the Wirral Peninsula, but there are certainly two remarkable hosts.

My thanks to Philip Cowan and Dianne Simpson, who invited me to sleep in the late Lord Leverhulme's open air bedroom[1], have entertained my friends and family sitting in front of crackling fires and created treasured memories taking the boat and picnics out onto the lake.

In addition, they have given me one of Lord Leverhulme's account books, which has been under lock and key for over 100 years.

I owe them much.

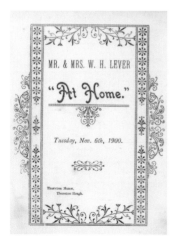

'At Home' invitation from Mr and Mrs Lever.

A Note from the Author

My pen, now redundant, has done its job. A loyal friend for over a year; close at hand when needed – a quiet, tolerant companion.

It shared my curiosity when we saw how much Mr Lever had spent on straw mattresses for his servants and I swear I saw it smile when it realised Mr Lever had made a fortune out of selling 'stinking soap'.

It joined me on the roof of Thornton Manor and rested while I slept.

It eyed me with disdain when I crossed out words only to replace them with the same. It breathed a sigh of relief, along with me, when we reached the last page.

Before you and I meet Mr Lever and the villagers may I share a thought with you?

On a cheerless, bitter day, when the heavens were almost dark at 3 o'clock in the afternoon and snow was threatening, I lit candles for company and made a pot of tea.

My unfinished book had remained closed for two days, waiting for me to record the last words.

When I opened it, the Victorian scraps seemed to leap off the pages and say: 'Never mind that the wind is unkind and the day is cold. Glance through these pages and your heart will be warmed.'

So I did, and it was.

Therefore, when the skies are unfriendly and the days are short, I hope you will open this book and find something to warm your heart too.

Jo Birch
Port Sunlight
Winter 2016/17

Foreword

When I first heard that Jo Birch was writing this book, I could think of no better person to showcase how special Port Sunlight is.

As a village resident since 2005, Jo is in a unique position to convey what it's like both as a place to live and visit. She also embodies what it means to be a resident of Port Sunlight in the twenty-first century. Jo is passionate about the founder, William Lever, and his legacy, extraordinarily generous in sharing her love and knowledge of the village, and proactive in promoting and increasing access to the Leverhulme story, which is of national and international importance.

I first met Jo back in 2014. We were co-curating a series of events, activities and a special exhibition in partnership with village residents to celebrate the 125th Anniversary of the first Port Sunlight tenants. Jo invited us into her beautiful home to view her collection of Lever and Port Sunlight material, which she had amassed over nine years, to see if she could support our work in any way. Our eyes lit up when we entered; it was like an Aladdin's cave, and we pored over the treasured items.

Since that first meeting, Jo has curated her own exhibition in Port Sunlight Museum each year. We see her as an extension of the heritage team, a curator in her own right.

We are delighted that Jo is now being given an even bigger platform upon which to share her love of all things Port Sunlight, and in the 130th year of our village.

Katherine Lynch, Director of Heritage
Port Sunlight Village Trust

Introduction

'When I die,' Lord Leverhulme said, 'you will find the words 'Grocery Trade' engraved on my heart.'

After his death, one commentator observed: 'He was a man of steel but he was also pure gold.'

In this book, I attempt to relate unfamiliar stories from newspaper reports of the day and, using items from my personal collection, allow the villagers, workers, visitors to Port Sunlight, and, indeed, Lord Leverhulme himself, to speak to us in their own words.

This postcard, posted in 1907, started my collection. Although I found the picture appealing, the message on its back is what interested me most:

> Hope you will like this of a Port Sunlight house. We went over the works, saw the printing & box making, girls open air swimming bath, gym & large dining hall for girls & schools. Had tea in one of the houses with some members of British Womens Association. Is Frank at home? Love Mabel.

Some messages on the postcards in my collection are beginning to fade (many of them are over 100 years old), so to ensure legibility they are transcribed throughout the book.

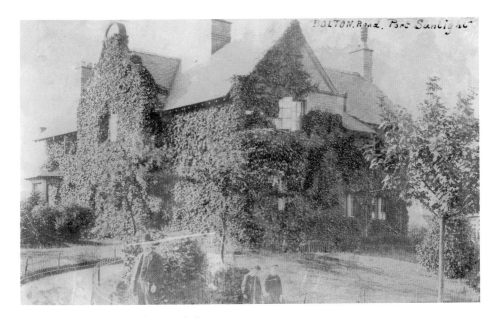

Postcard posted in 1907 from Mabel.

1

Before Port Sunlight

How far back shall we go?

Will you let me start one Christmas Eve, two years ago, at Thornton Manor?

I was invited, with other guests, to spend the evening with Philip Cowan and Dianne Simpson in their magnificent home.

During the evening, Philip and Dianne beckoned me away from other friends enjoying comfort from roaring log fires and I followed them into a room which was once Lord Leverhulme's office at the manor. That room, to me, contains the very heartbeat of Lord Leverhulme. I can almost hear him speak.

The large safe in which Lord Leverhulme kept his most important documents is tucked away in a corner.

Philip produced a key from his pocket, opened the safe, reached far into its dark depths and retrieved an accounts book which had been guarded within that fortress for over 100 years. He then handed the book to me as a gift. I could not find the words then to express my gratitude and I cannot find them now.

That generous gesture prompted me to write this book.

Let's join Mr Lever in the quiet of his study.

One knows from the very sight of the book – without opening it – that valuable information lies within. Why else the key?

Shall we peep inside?

Entries are made by a young Mr William Hesketh Lever.

Let us peer over his shoulders and see what he has recently recorded in the book he started to keep in 1874, when he was twenty-three years old.

The year is 1881, and Mr Lever is thirty years old – seven years before the building of Port Sunlight begins.

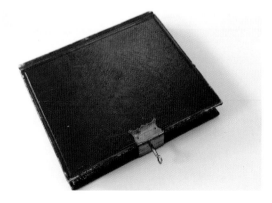

Lord Leverhulme's account book. (Photo Tom Hughes, Port Sunlight Museum)

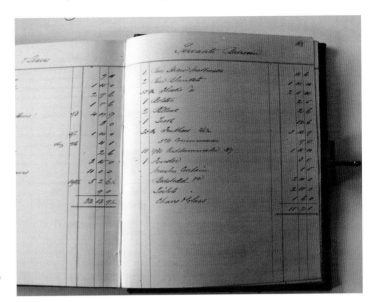

Extract from account book relating to the servants' bedroom. (Photo Tom Hughes)

Mr and Mrs Lever are living at 21 Upper Dicconson Street, Wigan, and Mr Lever has just furnished a bedroom for his servants:

1 pair straw mattresses	11s 6d
2 pair blankets	£1 10s 4d
50 lbs flocks	£2 5s 10d
1 bolster	2s 5d
2 pillows	2s 6d
1 tick	12s 6d
30 lbs feathers	£3 13s 9d
5 per cent commission	9s 0d
10 yards Kidderminster	£1 15s 10d
1 fender	3s 0d
Muslin curtain	1s 5d
Bedstead	£2 10s 0d
Toilets	£2 18s 0d
Chairs and glass	£1 6s 0d
Total	£18 2s 1d

As this inventory shows, Mr Lever's planning was meticulous, something which becomes apparent time and time again. Was this part of the reason for his remarkable success?

Here, he equips the kitchen:

Plate Basket	3/3	Knife Basket	1/10		5	1
Manila Bag	1/2	Kneeler	1/-		2	2
Salt Box	3/6	Soap box	5d		3	11
Mat	3/-	Brushes	11/3		14	3
Mugs and Jugs	20/8	Copper Kettle	11/-	1	11	8
3 Sauce Pans	7/2	Knife board	1/6		8	8
Water bucket	3/-	Paper	2/-		5	0

Item	Price	Item	Price	£	s	d
Fender	15/6	Hanging Bar	1/3		16	9
Draw Plate	1/8	Washing-up Tin	4/6		6	2
Hand Bowl	1/9	Frying Pan	1/3		3	0
Cullender	1/6	Gravy Strainer	1/6		3	0
Enamelled Grid	3/6	½ doz. Com knives	6/-		9	6
Dripping Pan	2/6	4 Gross Nails	4/8		7	2
1 doz. Ivory Knives	27/6	1 doz. Dessert knives★	21/6	2	9	0
Pan Cover	8/6	Game Carvers	8/6	1	7	0
1 Steel	4/-	Set Skewers	1/2		5	2
1 Pair Candle Sticks	2/-	Clothes Baskets	5/4		7	4
Home Washer				7	16	0
Wine Rack				1	1	0
Hammer	2/3	3 Hot Irons	4/-		6	3
				18	18	1

★Shown as ditto in accounts book

Item	Price	Item	Price	£	s	d
		Brought forward		18	18	1
1 Case Emery	1/-	Potato Knife	7d		1	7
1 Brass Pan	6/-	1 Tin and Iron Pan	3/6		9	6
1 Pan and Cover	6/-	1 Knife Tray	4/6		10	6
Housemaids Box	5/6	Slop Pail	5/6	1	1	0
Candle Box	2/-	Dust Shovel	1/4		3	4
Kitchen Dusters	4/6	Coal Hammer	1/3		5	9
Kitchen Fire Irons	5/3	Emery Cloth	9d		6	0
Toasting Fork	6d	Chopping Knife	1/3		1	9
2 Tea Trays	11/-	2 Dredgers	1/3		12	3
2 Graters	10d	1 Oven Rake	7d		1	5

Victorian scrap. Servant.

1 Cinder Sifter	9/6	Egg and Fish Slice	1/6		11	0
Sugar Canisters	4/-	Sundries	5/9		9	9
9 Metal Spoons	3/9	1 Flat Iron Stand	9d		4	6
1 Best Metal Teapot	11/6	1 Pint Mug	7/6	1	9	0
1 Box Iron	3/9	1 Saucepan	1/5		5	2
1 Sardine Opener	6d	1 Pair pincers	1/4		1	10
1 Screwdriver	1/9	1 Beer Tap	3/3		5	0
2 Gilt Bread Plates	2/4	Sundries	2/10		5	2
½ doz. Plates	3/9	Sundry China	6/1		0	10
		Carried forward		25	12	4
		Brought forward		25	12	4
1 Tea and Breakfast Set				2	8	0
Sundry China	19/6	Ironing Blanket	16/9	1	16	3
Kitchen Clock				2	17	6
Spoons and Forks				4	18	0
Dessert Forks				2	0	0
Tin Oven	14/-	Table	14/-	1	8	0
2 Pitch Pine Dressers				18	0	0
1 Painted Dresser				3	18	0
3 Chairs	18/-	1 Rocker	11/-	1	9	0
Oilcloth	4/0/0	Felt for Lining	11/8	4	11	8
1 Kitchen Chair	6/6	Gas Boiler	16/-	1	2	6
Wire Blinds				1	10	0
				71	11	3

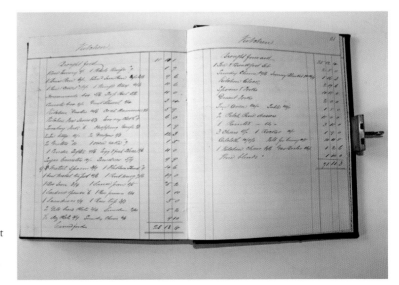

Extract from account book regarding the kitchen. (Photo Tom Hughes)

Come, join me. One of the servants has lent me a key…

The house is an end-of-terrace town house from 1877. All the windows are sashed without glazing bars. The unusually complete survival of original features and fittings are as follows: an internal porch with square-panelled dado and embossed wall covering with sunflower motif; stained and painted glazed screen with roundels of birds and flowers and a border of yellow leaves and flowers; a hall with 'Aesthetic Movement' embossed dado including fish, lilies and butterflies, with an upper border of birds and a cornice with egg-and-dart and modillion enrichment; a front parlour with Adam-style moulded plaster frieze, a panelled ceiling, a column to the right of the window apparently for air-conditioning, a fireplace with heavy surround of grey marble and grate with decorated hood, a panelled door with embossed rectangular panels, a marble fireplace (now painted) with copper hood to grate and a door like that to the parlour; a staircase with dado continued from the hall and cast-iron balusters continued along the landing and up to the attic; a full-width first-floor drawing room with arched white marble fireplace, and there is a similar fireplace in the middle bedroom; a bathroom with wooden-panelled dado (part missing); a two-room attic; and a complete suite of five cellar rooms, with ducting that appears to have been related to an air-conditioning system.

The house was occupied by W. H. Lever, subsequently Viscount Leverhulme, founder of the soap-manufacturing empire, at the time when he was founding his business in Wigan. The interior decoration and fittings of his house are early evidence of the artistic interests of Lord and Lady Leverhulme, and of the earliest origins of the Lady Lever Collection.[1]

Shall we leave Mr Lever and his account book for a while? He has a lot to do; within seven years of making these precise entries in his account book, his busy mind will have spurred him on to establishing one of the greatest soap factories the world has ever known.

The name of his soap would be recognised by every family in the land, and in later years by many people across the world.

His product would be supplied to HM Queen Victoria's household and to housewives alike, in their back-to-back terraced houses across the country.

We will return to Mr Lever's account book once again much later, but the next time we glance over his shoulder he will have created Port Sunlight and his place of residence will be the noble Thornton Manor.

This postcard of Thornton Manor refers to it as being the country seat of W. H. Lever Esq. MP. Mr Lever was elected Liberal MP for the Wirral Division of Cheshire in 1906.

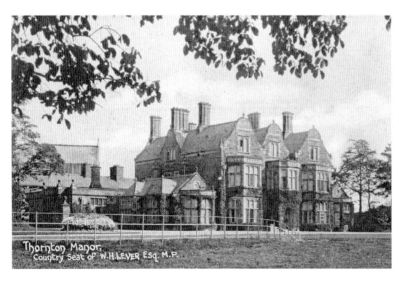

Postcard.
Thornton Manor.

2

Stinking Soap

How many people would see potential in a bar of soap that was described as stinking? I wager not many but Mr Lever, who was self-confident, recognised a good thing when he saw it, and was able to see beyond what was immediately in front of him.

One day a shopkeeper asked him if he could supply more of that 'stinking soap' because it was selling so well, despite its smell.

This soap was made from vegetable oils (as opposed to tallow, a widely used ingredient), but oxygen in the air oxygenised the oils and made it rancid, creating an awful smell.

This was not a problem for Mr Lever – use citronella as a lemon scent, stop the soap being exposed to air by wrapping it in imitation parchment, come up with a memorable name – Sunlight – and finally package it in a brightly coloured, eye-catching box.

If that wasn't enough, a declaration on each packet: £1,000 Reward! Will be paid to any person who can prove that this soap, manufactured by Lever Brothers, Port Sunlight, Limited, England, contains any harmful adulterant whatsoever.

Who could resist such a product?

Mr Lever knew he was on to a winner and no one ever extracted that £1,000 reward from the soapmaker's pocket.

This postcard, posted in 1909 to Miss A. Leigh, Police Station, Heyes Lane, Alderley Edge, Manchester, says: 'This is the place where they boil d _ _ _ d m_ _s for your scented soap. I am just looking at the *Muratania* (sic) in the river. David.'

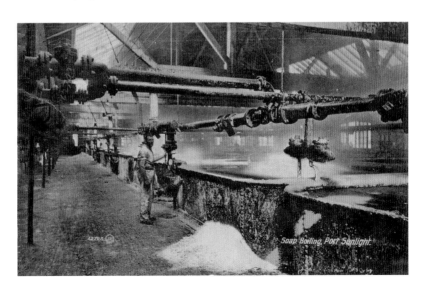

Postcard sent
by David to
Miss A. Leigh.

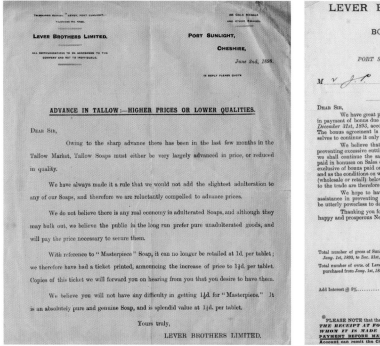

Left: Lever Brothers advise a price increase.

Right: A letter dated 31 January 1894 advising this shopkeeper of the bonus of *5s 3d* earned on the sales of Sunlight Soap.

A Symphony in Soap

I make no apologies for reproducing part of this article from the *Portsmouth Evening News*, Saturday 21 June 1890, and I confess to stealing its title from the report because how can I better it?[1] Let's leave whatever we are doing and join these visitors as they take a tour of the factory…

There seemed only one thing to do when we were asked by Mr Martin Harvey, the shrewd and popular South of England representative of Messrs Lever Bros, to become one of a party of inspection to the huge works at Port Sunlight, which are famed for the manufacture of Sunlight Soap. We had long been struck with the extraordinary boldness and energy of the Sunlight firm.

There had been no escape from them. Wherever we walked, or rode, or sailed, there were placards to proclaim the merits of this article, and to declare that it had the largest sale of any soap in the world. Every hoarding had something to say about it, and every grocer's shop in every town somewhere or other, in familiar blue, the fact that Sunlight soap was to be had for the asking. 'People will have it,' a grocer once said to us. 'We don't know much about the firm but there is no denying the demand.' If grocers didn't know much about the firm then, there is no firm about which they know more or have kindlier feelings towards today, thanks to the circumstances which are the occasion of this article. Messrs Lever Bros are young men. Up to four years ago they had been grocers in Warrington and had latterly become soap manufacturers in a small way. Four years ago, finding that their manufacture was making headway, they declined all other business and devoted themselves entirely to soap. Fortune – which means their own

courage and good faith with their customers – favoured them from the first. Their works at Warrington had to be enlarged again and again, until not another inch of space was to be had and still the orders grew. They had to choose between refusing business or going elsewhere. At that time a splendid situation on a deep water creek just above Birkenhead presented itself. The Messrs Lever Bros bought fifty-two acres at the price of agricultural land and promptly commenced to build their present enormous manufactory. A year ago the works were completed and named Port Sunlight. Pretty houses with gardens for the work people also rose as if at the touch of an enchanter's wand, and Sunlight soap, in larger quantities than ever, began to lather the faces of unwashed Britons, and make labour at the wash tub light. A short time ago Mr W. H. Lever and his brother conceived the honourable idea of inviting representative grocers to visit their works and judge for themselves as to whether the article they sold so largely was worthy of their support. These visits are now being made every week from every part of the United Kingdom. The visits are being carried out in a manner characteristic of all the Messrs Lever do, at once courageous and magnificent. Specially engaged saloon carriages convey the gentlemen chosen by the different Grocers' Associations to Liverpool; luxurious rooms are provided for them at the palatial Lime Street Hotel of the London and North Western Railway; they sup together, breakfast together and dine together with Mr W. H. Lever, while the whole process of manufacture is made as clear to them as sunlight. It was on an errand of this nature that the grocers of Hampshire were bound when Mr Harvey asked our representative to accompany them.

Waterloo station was the meeting ground on Tuesday afternoon. Twenty gentlemen journeyed from Portsmouth, twenty more came on from Southampton, three from the Isle of Wight and others were picked up on the way.

Liverpool was reached at half past eight and after supper, bed and breakfast, the visit to Port Sunlight was paid.

It was a revelation. A more perfectly laid out and organised manufactory could not be conceived. Pleasantly situated as it is beside the creek, its external aspect is one of solidity combined with lightness and considerable elegance. But the wonders of Port Sunlight are internal. Imagine a boiling room containing twenty-seven pans, each of them with a capacity of sixty tons! The amazing thing in wandering among those bubbling seas of liquid soap was the absence of any unpleasant smell.

It might have been toffee or butterscotch. It is in these huge pans, rivalling in size the great tun of Heidelberg[2], that the work of saponification of the raw materials is carried on. When this work is completed, the soap is allowed to stand for any sediment to settle and then it is run off through wooden spouts into frames, from which it is taken when cool and cut into bars and slabs.

We followed the soap further into the frame room, where never-ending wooden conveyors, which move on wheels throughout the entire establishment, run the gauntlet of a row of boys, who feed the army of stampers that keep the sixty stamping machines constantly going. This process resembles the minting of coins. The tablets then pass into the hands of the wrappers, and are packed into card boxes, and then into cases which stand awaiting their reception. Finally, conveyors take them right down to the side of the barges that lie at the wharf. The making of the cases is an interesting department. Those pieces which are to form the sides and ends of the box are printed with the name of the firm. They are passed through a printing press, a machine of rather more substantial build than the ordinary press, and receive the impression of a very handsomely engraved plate, which gives almost as clean and sharp an outline as the copperplate on a visiting card. The printed sides and ends are now nailed together by a machine which seems almost the acme of ingenuity in the way of invention. Into this a boy passes the boards, holding them together in the way in which they are to be fastened. He then presses a treadle and down comes a sort of guillotine which drives home six nails with one pressure, forcing the heads well in. The same process is gone through at each side or bottom and the box is complete. Eleven of these machines are employed, with a capacity for over 8,000 wood cases each day. The making of the card boxes in which they are placed previous to the final packing gives employment to from 350 to 400 girls.

The whole establishment is a triumph of organisation. There is no haste and no stoppage. Labour saving is carried to perfection; the system makes confusion impossible.

Mr W. H. Lever presided at the dinner on the same day in the great dining room of the London and North Western Hotel. His speech, like his manufactory, was all to the point – nothing superfluous.

He told how he wished to come into personal relations with those who had helped them as retailers to the position they occupied in the soap world, and they could think of no better plan than to invite them to visit Port Sunlight.

After songs and more speeches, gentlemen were free to finish the night as they desired and next day special saloons once more conveyed them, full of delight with all they had seen, back to the South from Liverpool, near Port Sunlight.

This postcard was sent from 16 Park Road, Port Sunlight, on 13 November 1907. It is addressed to Mr W. Dalby, 58 Tindall Street, Scarborough. It reads:

Dear Will, Just a line to let you know we are still living. I hope it will not be long before we are all together again. What do you think of the Sunlight girls with their pinafores on, I'll bet you felt shy going through the works. Please give my love to Aggie. Love from all. Jim.

Postcard sent to Will from Jim.

Victorian scrap. Train.

3

Global Advertising

Mr Lever took a considerable interest in advertisements, appreciating the impact a skilful one would have on sales. The following Victorian scraps depicting folk waving a flag advertised Sunlight Soap – rhymes were printed on the reverse of each globe.

I start with India – a country I first visited some years ago and became immediately spellbound by the hospitality offered to me by its citizens.

I have an Indian friend I have known for fifty years – our family have always called her Polly. The name stems back to when my mother met her while both worked at Warneford Hospital in Royal Leamington Spa. Mum used to visit Polly at her home for coffee. I don't think nursery rhymes were ever far from mum's mind (she had nine children and thirteen grandchildren) so she always said, 'Polly, put the kettle on' (from the nursery rhyme), and the name stuck.

There has never been a reason for Polly to relate the following to me but when I told her the subject matter of my book she recalled that, in the 1950s, when she was living in the Punjab, Sunlight Soap was being used in the house. It is a laundry soap, but she remembers people bathing in it. Washing her face with the soap one morning, her father stopped her from doing so, advising it was not be used on the skin.

'If you have ever wondered why I am so beautiful,' she said to me, 'it must be because I put Sunlight Soap on my face!'

She also told me her brother went to Agricultural University in the Punjab. The family kept a buffalo for its creamy milk. The buffalo gave birth to two albino calves, which the brother promptly named Sunlight.

I can see Lord Leverhulme smiling at the thought.

INDIA
'Hindoo maid, with eyes so bright,
Can you kindly tell me pray,
What you use each washing day
To make your pretty skirt so white'

'Can I tell you? That I can, Sir,'
Said the little maid, in answer,
'When we rub light with SUNLIGHT
The dirt will drop outright.'

Sunlight Soap has appeared surprisingly often on my travels around the world.

I noticed an immaculately dressed bus driver in Japan carefully rubbing the soap onto his soiled white gloves which were part of his smart uniform. He told me he would soak them when he got home that evening and the stain would disappear overnight.

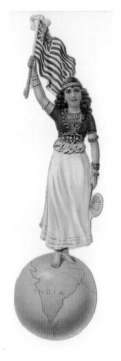

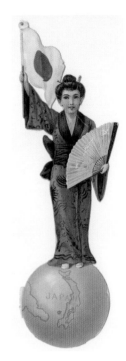

Left: Victorian scrap. India.

Right: Victorian scrap. Japan.

JAPAN
All up-to-date and wide awake is the
little Japanee,
No longer Asiatic but European she would be
Of all the Eastern peoples there is none so
blithe and gay,
For she knows full well the Japan-ease of
the world-famed SUNLIGHT WAY.

Watching a handful of vessels bobbing about on the water in Vancouver I spoke to a gentleman who told me Sunlight Soap was the best thing he had found to keep the decking on his boat clean.

CANADA
Merry as a slight bell, singing all the day,
Is the fair Canadian maid who knows the
SUNLIGHT WAY.
Swifter than her snow shoes glide along
the snow,
SUNLIGHT SOAP will wash the clothes,
as she has cause to know.

Denmark is included as I have a Danish friend called Anni who lives in Port Sunlight, and she would never forgive me if I omitted her homeland.

'That statue could do with some elbow grease and a good dollop of Sunlight Soap.' These were words not spoken by Anni, but overheard by me when I stood alongside two elderly ladies admiring the Little Mermaid statue in Copenhagen.

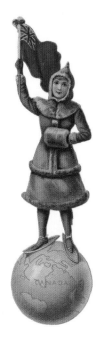

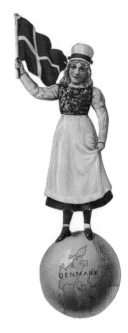

Left: Victorian scrap. Canada.

Right: Victorian scrap. Denmark.

DENMARK
This pretty maid is a little Dane,
who might by her dress be thought
Rather vain.
But everyone knows
She washes her clothes
With SUNLIGHT SOAP as sweet as
a rose.

I include Holland because of Unilever's Dutch connections.

The Lever Brothers soap company grew into what is known today as Unilever. Dutch firms Jurgens and Van Den Bergh joined together to form Margarine Unie. Margarine Unie then teamed up with Lever Bros to create Unilever.

I wonder if the young Mr Lever, cutting bars of soap in his father's grocery shop all those years ago, ever imagined 2.5 billion people on any given day, worldwide, using a Unilever product?

I bet he did. As you will see later in the book, Mr Lever could see into the future very clearly indeed.

HOLLAND
In the marshy land of the Zuyder Zee,
Housewives from washing day worries are free.
With the heaviest wash they easily cope,
For they know the value of
SUNLIGHT SOAP

Sunlight Soap was a brand known all over the world, but the Victorian scraps didn't neglect to include places closer to home.

IRELAND
SUNLIGHT SOAP, you've a
wondherful sthyle wid ye,
Washin's made aisy wid never a boil
wid ye.
Women who use ye have no need to toil
wid ye.
Och! SUNLIGHT SOAP! You're
the besht iv thim awl.

WALES
Maids of Cymru, ever smiling,
Washing days with songs beguiling,
You have one true friend the while, in
SUNLIGHT SOAP for aye.

SCOTLAND
There's nae luck aboot the hoose
There's nae luck at a',
There's nae luck aboot the hoose,
Gin SUNLIGHT SOAP's awa'.

Left: Victorian scrap. Holland.

Right: Victorian scrap. Ireland.

Left: Victorian scrap. Wales.

Right: Victorian scrap. Scotland.

Sunlight Soap in Stroud

After visiting my publisher in Stroud, Gloucestershire, I headed towards The Museum in the Park nearby. A captivating museum, Sunlight Soap is included in their laundry display.

Like the reporter who observed in 'A Symphony in Soap', Chapter 2 – there is no escape from the Sunlight firm, even today.

Have a look in your cupboards at home – in the bathroom, under the sink, in the larder, fridge and freezer.

How many Unilever products can you see?

A Well-Travelled Soap

Sunlight Soap was always the housewife's friend, but I suspect it deserved the title of traveller's companion too.

In 1910 Lever Brothers gave a gift of twelve dozen Sunlight Soaps and twelve dozen Lifebuoy Soaps (another Lever Brothers product) to the explorers planning their expedition to the South Pole.

Captain Robert Falcon Scott, leader of the expedition, sent thanks for the gift – and an order for the same quantity.

The envelopes on page 24 are colourful reminders of some of the places in which the name of Lever Brothers and Unilever were (and still are) recognised – Canada, China, Trinidad and Tobago.

Victorian scrap. Expedition to the
South Pole.

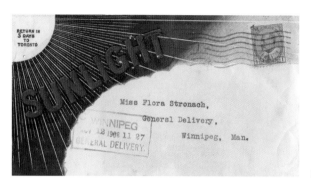

Sunlight envelope.

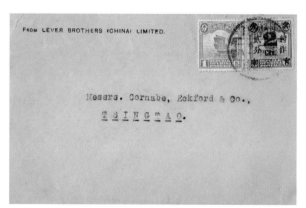

Envelope. Lever Bros (China) Limited.

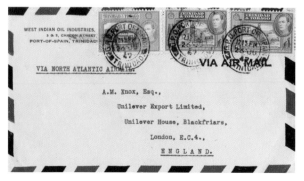

Envelope addressed to A. M. Knox.

The recipient of the envelope addressed to A. M. Knox Esq was Andrew Knox, born in Birkenhead, England, in 1903. Most of his career was spent on the overseas side of the Lever Brothers business. He rose from a junior in the India section of the company to a place on the main board of Unilever, which he occupied for sixteen years.

The book he wrote, *Coming Clean*[1], is worth reading, if you can locate a copy. It gives an insight into his time spent with Mr Lever, who was known as the 'Old Man' by those in personal contact with him. In 1924 Andrew Knox travelled with Mr Lever (who by then was Lord Leverhulme) and others to Hamburg, Berlin, Danzig, Stettin, Copenhagen, Stockholm, Oslo, Bergen and Newcastle. In his book he entertains us with anecdotes and recalls affectionately that, 'It is small wonder that the Old Man was and has remained the hero of my life and that fifty years later I can recall so clearly a brief fortnight's experience.'

It would have been impossible for Lord Leverhulme to have lived long enough to have read those words as Mr Knox's book was not written until 1976, but I wish he had.

What a heartfelt accolade from Mr Knox.

The following invoices also indicate how far away from home the Lever Brothers name was known; in these examples, Mhow, Suez and Bermuda.

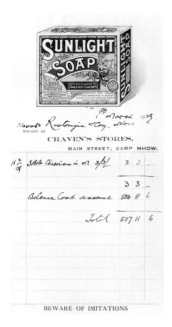
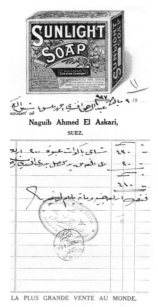
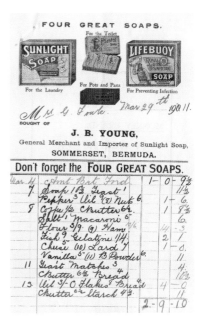

Left: Invoice. Mhow.

Middle: Invoice. Suez.

Right: Invoice. Bermuda.

4

Lord Leverhulme Speaks

A Picture Paints a Thousand Words

Lord Leverhulme always had 1,000 words (and more) up his sleeve. Would you like to share some of them with me?

Let's start with a photograph of the 'off duty' Lord Leverhulme, which was taken at the Chelsea Arts Ball, Albert Hall, probably New Year's Eve, 1922. The Chelsea Arts Ball, once said to be Britain's most scandalous New Year's Eve party, became known for its exuberance, excess and glamour. The Ball was always a highlight of the social calendar; a fancy dress extravaganza.

Note Lord Leverhulme's 'costume' here – frayed collar, cuffs and hem, with the coat being held together by at least one large pin. This was not a costume of the grandest design; as you will read in the chapter concerning his open-air bedroom at Thornton Manor, Lord Leverhulme felt quite at home with simplicity, as well as appreciating the finer things in life.

Lord Leverhulme at the Chelsea Arts Ball.

Happy Days Fifty Years Ago

The following piece was recorded in the *Dundee Evening Telegraph* on Friday 7 November 1919:

Lord Leverhulme, president of the O. P. Club, who is shortly leaving England for a tour of the world, was the guest of members of the Club at a farewell dinner at the Royal Adelaide Rooms, London. Lord Dewar presided over a large company.

Lord Leverhulme, responding to the toast of his health, indulged in one or two memories of his boyhood. He described his father as a man who believed in keeping his son short of money and his mother as a lady who believed in keeping her daughter short of clothes. (Laughter)

'My father gave me 7s 6d and a railway ticket,' said Lord Leverhulme, 'and for 7s 6d I had four days in the Lake District. Another time my father gave me 30s for a holiday of 14 days in the Isle of Man. I found a landlady who would sleep us two in a bed for 6d a night. We had breakfast – tea or coffee and bread and butter ad lib – for 6d a day and a similar tea for 6d a day. That left us another 6d for lunch. We had a meat pie, a tart and milk for 3d. For tea we had a tart and that left us enough, when we had saved up for a few days, to have a boat for an afternoon. (Laughter) That was fifty years ago and they were very happy days.

The O. P. Club

Trying to find out a little more about this club (for I had not heard of it), I came across this report from the *London Daily* news, dated Monday 17 December 1900:

Miss Leena Ashwell took the chair last evening at the inaugural dinner of the O. P. Club. Some people may think that the name requires explanation but inquiry last evening only led to bewilderment. Mr Carl Hentschel, the Hon Treasurer of the Club, simply declined to explain.

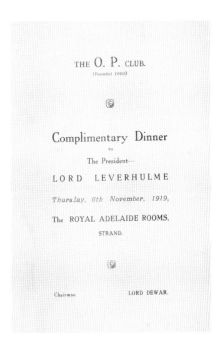

Complimentary dinner card. The O. P. Club.

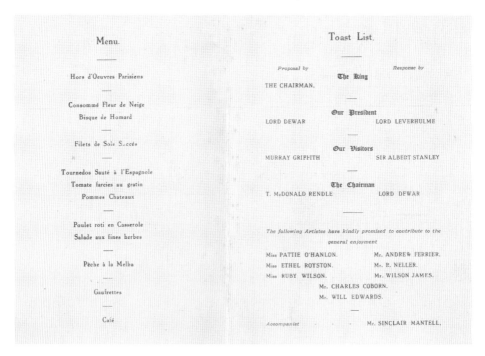

Menu. The O. P. Club.

Anybody, he said, could attach to the letters O. P. whatever meaning he or she pleased.

But an unofficial member of the new body was less reticent.

'Oh!' he said, 'we are the Old Playgoers' Club.'

Here was apparently confusion. It could not be an old club or this would not have been the inaugural banquet. The members were not old. Most of them were young and all were charming. It was necessary to seek further explanation from the unofficial member. He denied that the new organisation was a succession from the Playgoers' Club. The contrary was the case. The O. P.s were running on the old lines. The object of the club was to discuss matters relating to drama and its members were genuine playgoers.

Lord Leverhulme's Good Nature

This article was printed in the *Hartlepool Northern Daily Mail* on Friday 8 May 1925:

Here is a story of Lord Leverhulme which typifies the kindly side of his remarkable character. When he was in Melbourne last year he met with a young man who came from his own native town of Bolton. Always delighted to meet a fellow townsman (says 'Newsman' in the '*Daily News*') Lord Leverhulme spent some time in a conversation with him and then learned that the young man's mother was still living in Bolton.

'I'll call on her when I get back home,' declared Lord Leverhulme.

'I ought to tell you that unhappily she is in very poor health and very old,' said the other.

'No matter. I can bring her news of her boy,' Leverhulme replied and as soon as he was back in Lancashire he kept his word and brightened the old lady by bringing her a personal message from her son in faraway Australia.

Blunt Speech

Lord Leverhulme was the only person in Debrett described as a grocer. He was never ashamed that he began as a small shopkeeper and when his honours came to him he was not ashamed to say that he was proud of them.

When congratulated on a step up in the peerage by one of his directors, the creator of Port Sunlight said: 'Why shouldn't I be a Viscount? I suppose you are going to say I bought it.'

This bluntness of speech on personal matters was typical of him.[1]

Well-Travelled Mr Lever

Could Mr Lever see into the future? I think he could.

This is the comment Mr Lever made about the Chinese as he was visiting Chinatown in San Francisco during a world voyage: 'When one sees their wonderful industry, vitality and quiet persistent force, it is not hard to believe that they are destined to play a very important part in the future history of the world.' This was published in his book, *Following the Flag*, 125 years ago!

Mr Lever took notice of everything on his travels – where, perhaps, you and I might remark on the blue skies or lush vegetation, Mr Lever's observations were far deeper.

If you wait a moment I will come with you and we'll join Mr Lever in Honolulu, during his 1892 World Voyage. He is making notes in his diary:

Honolulu has a population of some 23,000 and supports one morning daily paper, one evening daily, and several weeklies, besides periodicals, but having no cable connection with the outside world, or even with the other islands of the group, and having only a bi-monthly mail service, it is not difficult to understand that the editor must find it almost impossible to provide news fresh each day for his readers. The following item, which was given a prominent position in the daily summary, I copied out of the Honolulu morning paper:

'Work on the new warehouse for W. G. Irwin and Co has been stopped for the present, the contractor having exhausted his supply of bricks.'

It is clear that the editor had exhausted his supply of news.

This was followed a few days later by a paragraph announcing that, the contractor having received a fresh supply of bricks, building operations had been renewed.

All this sounds very absurd to us; but if we imagine a city of only 23,000 inhabitants, separated by water from the rest of the world, with no telegraphic news, and mail arriving only at fortnightly intervals, we realise how the editor must find himself placed. This isolation, however, has the advantage of enabling the government to make more use of its prisoners than would otherwise be possible.

Not only are the prisoners employed in roadmaking, but they are actually hired out at 50 cents a day to whoever wishes to employ them. If citizens want the services of a 'handy' man to mow the lawn or weed the garden, they can telephone to the Governor of the jail and he will send up at once a 'felony' or a 'misdemeanour' or a 'drunk and incapable' or a 'burglary' or a 'manslaughter', whichever he has to spare at the time. Escapes are very rare, because, as it is almost impossible to get away from the island, pursuit and capture is certain. After an attempt to escape, the prisoner is condemned to work the rest of his term with a heavy chain and ball securely fastened to his legs.

Inside the jail the prison regulations are most easy-going, and on our visit there we were struck by the absence of the usual precautions to prevent escape. The walls were low and against them were placed

lean-to sheds, the roofs of which came to within six feet of the ground. All the doors of the cells were open – except those of a few persons awaiting trial for murder – and the prisoners were strolling about or lounging under a large tree in the centre of the enclosure; keeping watch over all was only one unarmed guard. In one part of the prison we noticed two women who were undergoing a long sentence for murder. The doors of their cells were wide open and these led into a corridor in which there was stationed no guard. This led into a passage in which was the entrance to the prison, where was stationed one solitary guard, armed with a short sword.

We found the two prisoners chatting together, looking out of the window at the end of their corridor. One of the women professed to be a native 'Kapoona' or witch-doctor; and had murdered a man, a woman and a young child with great brutality and cruelty, gouging out their eyes with burnt sticks and partially roasting them in full sight of a crowd of natives, many of whom had assisted her.

When Mr Lever was travelling abroad, his active mind was full of enquiry, and he was keenly aware of how other people lived – felons and law-abiding citizens alike.

Making Every Second Count

The gardens at Thornton Manor were designed by Thomas Mawson, a fellow Lancastrian. Mawson was a well-known designer of gardens and said that his collaboration with Lever was the defining professional relationship of his working life. In his autobiography[2] he states, 'The years 1905 and 1906 were the most momentous in my career. In the first place, it was in the year 1905 that I first met my client and friend the late Lord Leverhulme.'

Mawson had designed a carved folding screen for his parish church at Hest Bank, a small village in Lancashire.

He was looking for subscriptions to execute the work, and had obtained generous donations from several High Church Nonconformists, but had not raised enough money for the last panel.

He decided to write to Lever (neither men had met at this stage) and received the following letter as a response:

> I am very pleased to have the opportunity of sending you my cheque for the remaining carved panel in the screen of your beautiful village church, and wish you every success in your endeavours still further to improve its services. Now that you have had the courage to ask me for a subscription, may I be so bold as to ask you to come and advise me upon the improvement of my garden at Thornton Manor? I have wanted to consult you for the last two years, but all my friends warned me that it would be useless, as you never worked for anyone holding less social rank than a Duke, whereas I am only a poor and indigent soapmaker.

Mawson was then invited to stay at Thornton Manor for two days to discuss the plans for the gardens.

Mawson then describes: 'After dinner we had a long walk backwards and forwards on the south front of the house, discussing industrial problems, politics and certain aspects of sociology, in which I found him deeply interested.'

When the two men parted for the night Lever said, 'I shall be out in the garden at a quarter past six; I hope this is not too early for you. I can give you an hour and a quarter, and we breakfast at half past seven.'

How precise. Mr Lever did not waste a second.

I am grateful to the owners of Thornton Manor for not imposing such rigid time restrictions when I have stayed there.

5

Lord Leverhulme and Samuel Smiles

After Lord Leverhulme's death in 1925, the *Daily News* reported:

> In some respects Lord Leverhulme was an old fashioned figure. He had the tireless industry, the devotion to detail, the horror of waste, the absorption in his business as a thing good in itself which were the hallmarks of an elder generation of commercial princes. He was in the best sense of the word a self-made man and quite justly proud of it. Samuel Smiles would have delighted in him and seized exultantly upon his career to point the moral of the industrious apprentice, which, indeed, it does. But Lord Leverhulme was a good deal more than an unusually successful industrious apprentice. He had vision: he knew how to use money as well as how to make it. Port Sunlight alone proves that and the experiment of which it is the outward expression will be his most abiding title to fame. It is possible to criticise him. It is not possible to replace him.

The preceding opinion refers to Samuel Smiles, a Scottish author and government reformer. He was also, at various times, a doctor, a newspaper editor, a railway secretary and an insurance official.

One of the books he wrote, *Self Help*, was given to William Lever as a youth, and the contents left an indelible mark in the mind of the young Mr Lever. I am not surprised as many thought provoking passages are contained within the covers of the book.

Here are his thoughts on time:

> Men of business are accustomed to quote the maxim that Time is money; but it is more; the proper improvement of it is self-culture, self-improvement and growth of character. An hour wasted on daily trifles or in indolence would, if devoted to self-improvement, make an ignorant man wise in a few years and, employed in good works, would make his life fruitful and death a harvest of worthy deeds. Fifteen minutes a day devoted to self-improvement will be felt at the end of the year. Good thoughts and carefully gathered experience take up no room and may be carried about as our companions everywhere, without cost or encumbrance. An economical use of time is the true mode of securing leisure: it enables us to get through business and carry it forward, instead of being driven by it. On the other hand, the miscalculation of time involves us in perpetual hurry, confusion and difficulties; and life becomes a mere shuffle of expedients, usually followed by disaster. Nelson once said, 'I owe all my success in life to having been always a quarter of an hour before my time.'
>
> Some take no thought of the value of money until they have come to an end of it and many do the same with their time. The hours are allowed to flow by unemployed and then, when life is fast waning, they be-think themselves of the duty of making a wiser use of it. But the habit of listlessness and idleness may

already have become confirmed and they are unable to break the bonds with which they have permitted themselves to become bound. Lost wealth may be replaced by industry, lost knowledge by study, lost health by temperance or medicine but lost time is gone forever.[1]

I think we will leave Samuel Smiles here. He was once described as 'a man without pretence, blessed with plain reason and with common sense'. One could almost be describing Lord Leverhulme.

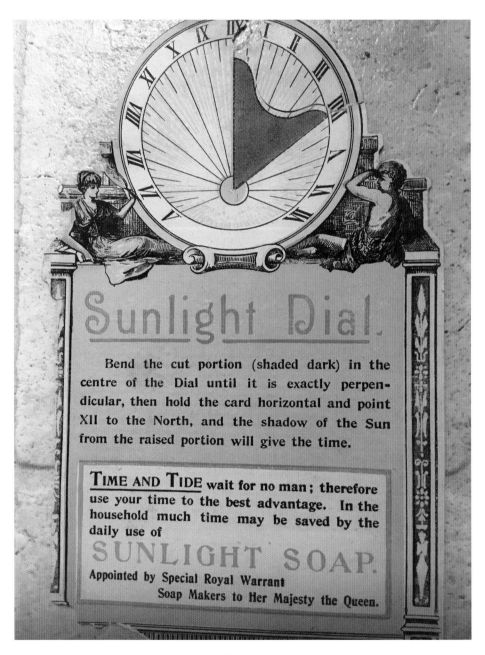

6

Villagers Speak

This postcard was sent from Bath Street, Port Sunlight, on 28 July 1914.[1] It reads:

> Dear Nettie. Just a P.C. showing the Boys & Girls playing at shop in our school. Yours affectionately, Pa, E. Taylor. Parcel on its way.

Postcard from Pa to Nettie.

The message on the back of this card, which is unposted (and I have taken the liberty of inserting punctuation, for there is none on the card), reads:

> I cannot get one with our house on. The one in the corner is next to mine. Ours is exactly same only more open. We have hot & cold water over & same over the bath. We have two places down & four bedrooms. It is a very large kitchen – it goes under two bedrooms. We have a big range nearly all steel to keep bright but it looks lovely when done. This is all this time. Hoping you will write to me.

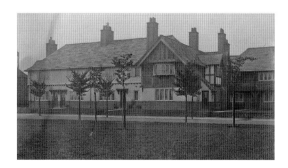

Postcard from the owner of a
four-bedroomed house on the Diamond.

When I read this postcard describing a house on 'The Diamond'[2] (page 33), I thought the writer sounded proud of their new home.

ENGLAND
The happy homes of England
How beautiful they stand
Made bright and sweet and clean within
With soap of SUNLIGHT brand.

A simple message on the back of this postcard from Bath Street reads 'Home Sweet Home'.
The signature on the back of this postcard from Bolton Road is indistinct. It was sent to Miss C. G. Firth, Sefton Park, Liverpool, in 1904. The message reads:

Thanks for your postcard. I was all right on Sunday. I will write tonight. On the other side of this postcard where the arrow is our house but it is hidden by the trees. Hope you like it.

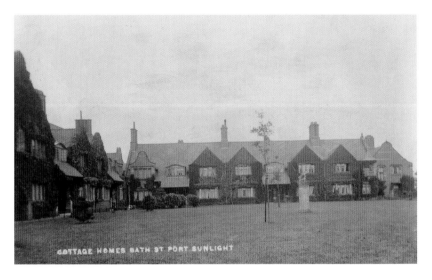

Above left: Victorian scrap. England.

Above right: Postcard. Home sweet Home.

Left: Postcard sent to Miss Firth.

This postcard was sent from 6 Lodge Lane, Port Sunlight, in 1911:

> Dear Fred. I am liking it fine here and I have got a good place. I am fairly took up with the village for everything is so nice, quite different to Haslingden. I shall most likely see you a week on Saturday as I am coming home then. I hope you are both in the best of health as I ask. Jim.

Sent from 3 Boundary Road, Port Sunlight, in 1914, the writer, Reg, addresses his postcard to an address in Halifax:

> Dear Cliff, Just a line to you as I promised. I am enjoying myself fine. Yesterday I went to look through Lever Brothers works. This morning I am going to the open air swimming bath and this afternoon I'm going to New Brighton. I will tell you more later, Reg. Tell Allan I can't write to him without his address.

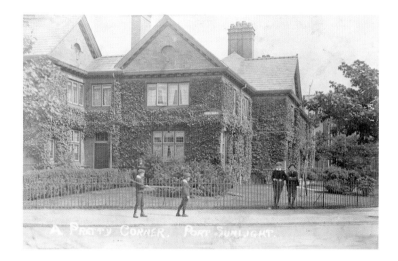

Postcard from
6 Lodge Lane.

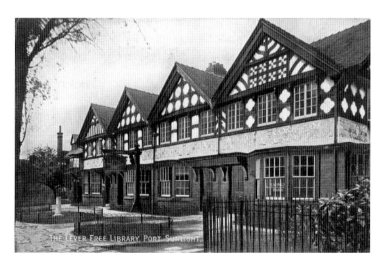

Postcard from
3 Boundary Road.

7

Visitors Speak

I love the message on the back of this card, posted on 15 July 1914:

> Dear Maggie, John and I are swanking to our hearts content at Port Sunlight in (Sunlight). Tommy.

Addressed to Miss A. White at the 'Herald Office' in Douglas, Island of Man, the writer of this card informs the recipient that she has:

> Just been and bought some soap for Mother. Yours till death, Ophelia.

Posted on 16 June 1904, and addressed to Mrs Le Masurier in Jersey, Channel Isles, the card on page 37 reads:

> I am at an exhibition in the village today. The houses are all in this style and are built by the Sunlight soap company for their workpeople. I cannot get a Pears cyclopaedia. Hope you are well. Where are you going this summer? [The writer's name is indistinct, but I think it is Gordon.]

 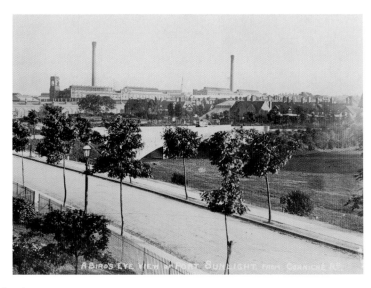

Left: Postcard from Tommy to Maggie.

Right: Postcard addressed to Miss A. White.

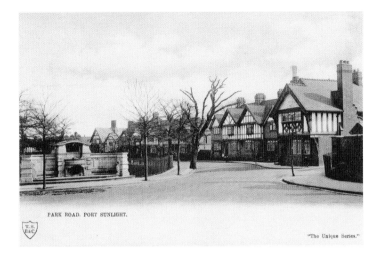

PARK ROAD. PORT SUNLIGHT.

"The Unique Series."

Postcard sent to
Mrs LeMasurier.

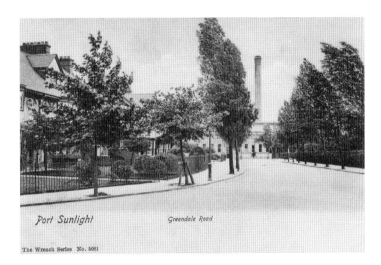

Port Sunlight *Greendale Road*

The Wrench Series No. 5081

Postcard sent from Jenny.

Another short one proclaims:

Have been through the works here. Jenny.

The postcard of the General Offices on page 38 states:

Dear Evelyn & all. We have spent a 1/2 day here, had tea in the building, beautiful place. Love Mum & Dad.

Written on 21 April 1907 and pictured on page 38:

This p.c. is from mother but I am writing on it. It is a view of the house where Grannie Hewer lives in Port Sunlight. She used to live in the one by the handcart but now lives in the other end one just over the printing. I am hoping to see you when I have my holidays but I don't wish to 'fly around' much as I like a restful holiday. I expect the dates will all be fixed up by the end of this week. With very best love from your affectionate [signature indistinct – I think either Bert or Beryl].

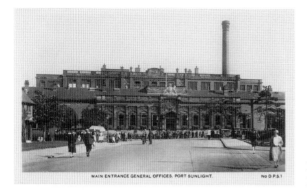

Postcard sent to Evelyn and all from Mum and Dad.

Grannie Hewer lives here.

Postcards featured on pages 39 and 40:

Dear Daddy, We have just been through Sunlight soap works. It took 11/4 hours to go through and is very interesting. They have given us a sample of soap each. We are now sitting on a seat by a bowling green. Going to Aunt Jeanie now. Love from David.

This lovely little place – not so little. We came here on Tuesday and went all over the works. Winnie.

Arrived after a good journey. Weather unsettled. Been over these works this afternoon. Decent Digs. Annie.

Dear Harry, We got here about 8.30. After breakfast we went through Port Sunlight. We have just been down the docks and seen the *Lusitania*. Which (sic) you were here. John.

Owned and operated by the Cunard company, the *Lusitania* was torpedoed on 7 May 1915. She sank in under twenty minutes and over 1,000 people lost their lives.

One of the four propellers that drove the ship across the Atlantic can be seen on the quayside outside the Merseyside Maritime Museum in Liverpool. It was the most complete of the three salvaged from the wreck off southern Ireland in 1982. The museum bought the propeller in 1989.

The postcard of RMS *Lusitania* (page 40) is neither a postcard from Port Sunlight nor one from a visitor but I hope you don't mind me including it. I have a passion for Cunard and their ships, past and present, and the message shows us what someone thought of the *Lusitania* at the time. The quality of this postcard is good enough to reproduce in its entirety.

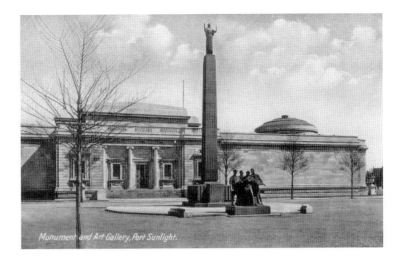

Postcard sent from
David to Daddy.

Postcard from Winnie.

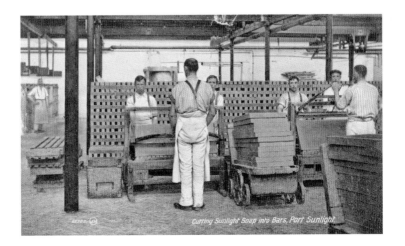

Postcard sent
from Annie.

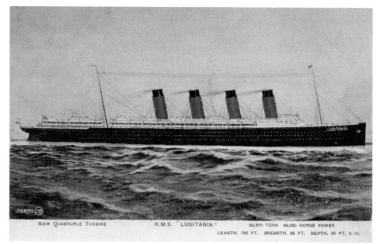

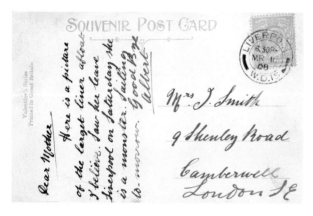

Above left: Postcard sent from John to Harry.

Above right: Postcard posted in 1908. RMS *Lusitania*.

Left: Postcard. Albert watches the *Lusitania* leave Liverpool.

A connection exists between Cunard, Thornton Manor and Port Sunlight. Before Lord Leverhulme bought Thornton Manor he rented it from Sir William Bower Forwood, who was both a director and deputy chairman of the Cunard Line. Today, when Cunard ships visit Liverpool, Port Sunlight is usually one of the trips offered to passengers as a 'must see' destination.

A Charming Booklet

Sharing lunch with friends, Joanne and Kevin, I was introduced to Joanne's parents, Pam and Alan. During the meal Alan mentioned a booklet he had created at school in 1953.

The title of this neatly written, beautifully illustrated pamphlet is 'My visit to Liverpool'. It includes a reference to 'Port Sunlight's great soap factories.'

It is enchanting, and far too important to sit in a drawer for the rest of its days, so with Alan's permission I reproduce part of the work on page 41.

The map in this booklet, so carefully drawn by Alan, reminded me of the cover of a *Progress* magazine issued by Lever Brothers in 1930 (see page 42).

A quote from W. H. Lever in 1909 appears in this edition of *Progress* (page 42):

Let no business man ever be afraid to laugh. Laughter is the best tonic the world ever knew and equally stimulates every nerve and muscle of our being.

 It makes our blood go coursing through our bodies at such a pace that the worries that were poisoning our mind have to stop their fooling and leave us free for honest, healthy and therefore profitable and pleasurable work.

I include the Victorian scrap on page 42 because it looks as though the cats agree that 'laughter is the best tonic the world ever knew'.

'My visit to Liverpool' by Alan Carey.

'Our Journey' by Alan Carey.

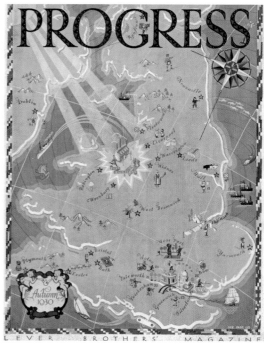

Above left: 'Map of Journey' by Alan Carey.

Above right: *Progress* magazine, autumn 1930.

Left: Victorian scrap. Happy cats.

<div align="center">

8

RMS *Titanic*

</div>

A chapter, I understand, can be as short or as long as the author wishes it to be. This chapter is brief, as was the life of the *Titanic*, but I include it because a connection to Port Sunlight exists.

On 6 April a lady by the name of Elizabeth Leather stepped onto RMS *Titanic* and signed on as a first-class stewardess. She gave her address as 28 Park Road, Port Sunlight. Her monthly wage was £3 10*s*.

Elizabeth survived the sinking and was rescued by RMS *Carpathia* from lifeboat No. 16 – the same lifeboat occupied by one of the most famous *Titanic* survivors, Violet Jessop, who had also joined the ship as a first-class stewardess.

Eight musicians had boarded the *Titanic* on 10 April 1912. Five days later they were playing as the ship went down. One of those musicians, who had been living in Liverpool, was John Frederick Preston Clarke. He was a member of the Port Sunlight Philharmonic Society.

First-class passengers on board the ship found Vinolia soap in their cabins (Vinolia Co. Ltd had been taken over by Lever Brothers in 1906).[1]

I have often wondered why Sir William did not book passage on the *Titanic*. The ocean liner was carrying some of the wealthiest people in the world and Sir William was certainly one of them. I suspect family matters were more important. Sir William and Lady Lever's only son, William Hulme Lever, was getting married on 24 April 1912, and preparations were being made for this joyous occasion.

There was another event to mark in the Lever household a little more than a week before the wedding – Sir William and Lady Lever's 38th wedding anniversary. The date? The very day *Titanic* sank to her final resting place – 15 April 1912.

Vinolia soap box. (Photograph Tom Hughes)

9

Christmas and Winter in Port Sunlight and Beyond

Victorian scrap. Snowball fight.

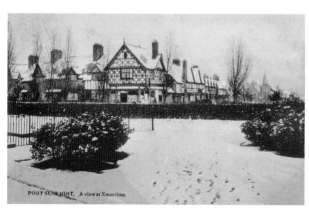

PORT SUNLIGHT. A view at Xmas time.

Postcard. A view at Christmas time.

Aah! Winter! Candles by four o'clock, kettle whistling on the hob, fireside chairs close to hearth, toasting fork and tea cups ready, curtains tightly closed, shutting out winter's moan.

The following card was sent from John McDonald, 31 Pool Bank, Port Sunlight, in 1907: 'A Merry Xmas and many more to follow.'

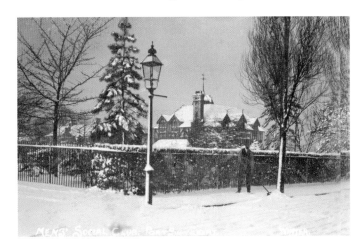

Postcard sent from
31 Pool Bank.

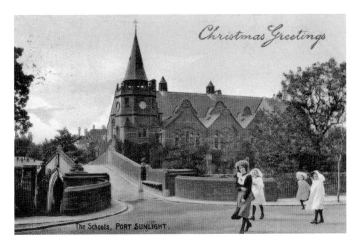

The schools send
Christmas Greetings.

Victorian scrap. Even robins
love Sunlight Soap.

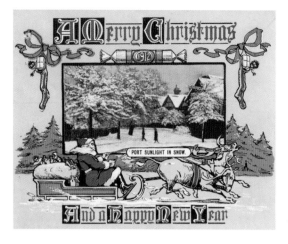

Village Christmas card, 1912.

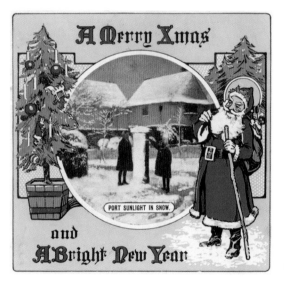

Village Christmas card. 'Last one posted'.

Christmas card. A country scene.

❦❦❦

May the Joys of Christmas be Yours and
Prosperity Crown the
Coming Year
is the Sincere Wish of
Edith Coolledge.

9, Primrose Hill,
Port Sunlight.

Sent from Edith Coolledge, 9 Primrose Hill.

Onward as the years are
creeping, All that Time within
its keeping, Holdeth worthy
of the reaping, May You reap.

Christmas card bearing the initial 'G'.

Love and joy attend you,
As life's stiff hill you climb;
And the starshell of contentment,
Hang o'er you all the time.

Christmas, 1920.

For the Past—
Remembrance;
For the Present—
Good Wishes;
For the Future—
Bright Hopes.
From
Eric C. Grant

11 Bath Street,
Port Sunlight.

Sent from Eric C. Grant, 11 Bath Street.

In his book *Coming Clean*, Andrew Knox tells us: 'We looked in lively expectation at Christmas time for the present from Mr and Mrs Lever as it was sure to be grander than anything we could expect from other sources.'

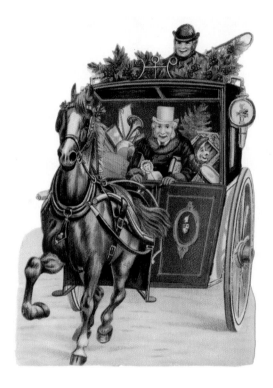

Left: Victorian scrap. A jolly Christmas delivery.

Below: Christmas card. Bright hours.

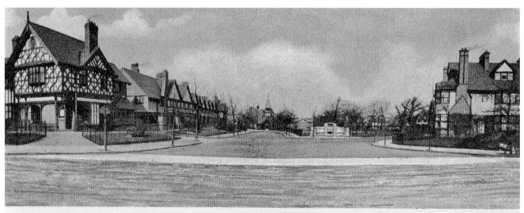

Bright Hours and naught but Happy Days for You and Yours.

Mr. and Mrs. Lever.
Mr. W. Hulme Lever.

Thornton Manor,
Thornton Hough, Cheshire.

Accept the best of Good Wishes for a
Happy Christmas
and all Good Fortune during the
Coming Year.

Christmas, 1907. New Year, 1908.

Sent from Mr and Mrs Lever and their son, 1907.

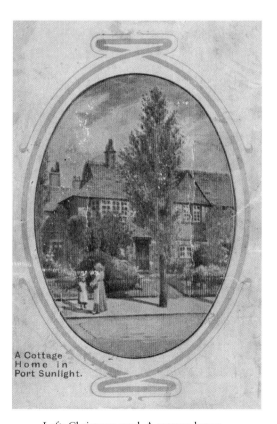

Left: Christmas card. A cottage home.

Right: Greetings from the King!

The lake in the grounds of Thornton Manor froze in 1933. An inscription on the back of one of the following photographs states: 'Skating on Lake, Lord Leverhulme's Grounds. 28 January 1933'.[1]

Victorian scrap. A hazard of winter.

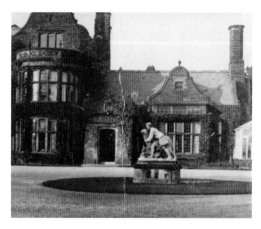

Thornton Manor.

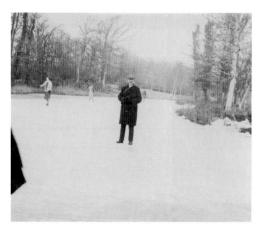

Frozen lake at Thornton Manor.

Well wrapped up.

Enjoying the ice.

Right: Christmas card. On the Belgian Congo.

Below: Sent from Sir William and Lady Lever, 1912.

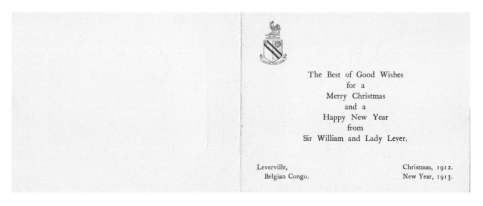

10

Children and Schools in Port Sunlight

Come and Live with Us

The following incident was reported in the *Lancashire Evening Post*, dated Thursday 7 May 1925:

> During one of the annual outings of the children of Port Sunlight, Mr Lever was asked by two little girls to go with them on a 'merry-go-round'. He laughingly consented and as they were going round one little girl said, 'Mr Lever, I've been on one of these before at New Brighton. I've got a rich aunt there.' 'Oh indeed!' said the soap king. 'Yes,' went on the little one,' she has got £200 saved up.' 'But you've got more than that, haven't you, Mr Lever?' enquired the other child. 'Well, you know,' replied Mr Lever with mock seriousness, 'I keep spending my money and you can't have your money if you spend it, can you?' 'And are you very poor now?' asked the first little girl anxiously. 'Well,' said Mr Lever, 'I keep spending and whatever shall I do when my money is all gone?' Without a moment's hesitation both his small companions shouted at once: 'Come and live with us!'

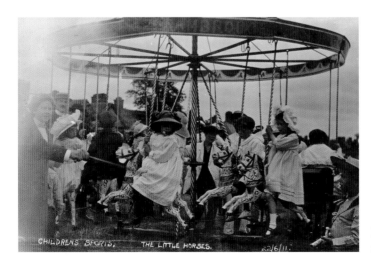

Postcard. Join us on the merry-go-round.

The following postcards show schools in the village. The schools by the Dell Bridge were opened in 1896. Their successor, the school in Church Drive, opened in 1903.

Victorian scrap. An important lesson.

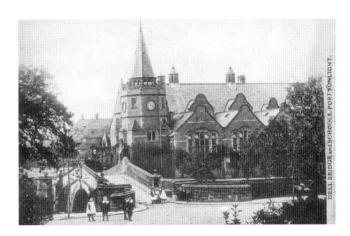

Postcard. Going home from school.

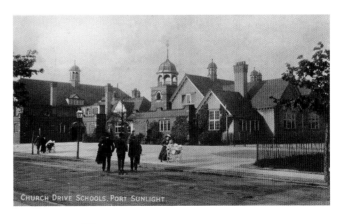

School inspectors?

Victorian scrap. Happy children at school.

A school for over 500 children.

The text on the reverse of this Victorian scrap mentions an article on 'The Housing of the People' in the *Sunlight Almanac* for 1900. Here is part of that article:

Let us glance for a moment at one bright spot on earth where the sun looks down on as happy and contented a community of workers as it is possible to conceive.

That spot is a centre of interest for thousands of visitors annually from every corner of the Kingdom, from every quarter of the globe – visitors of every rank and calling, who are curious to see with their own eyes this most surprising thing. For it is by no means a commonplace everyday occurrence to find a manufacturer supervising not only the direction of one of the most gigantic industries this nineteenth century can boast of but likewise the conception and erection of one of the most charming industrial villages imaginable.

Listen for a moment to what a prominent artist said of the place:

It appears to an artist rather as a sketch than a finished picture. It is full of possibilities. Quaint and peaceful, it suggests an old Surrey village, lacking only those touches which that great artist Father Time alone can give. It is now an untoned picture, requiring the master hand of Time to finish, and by deft touches to bring to that harmonious whole which was evidently the conception of its designer. The red roofs will become glorious in colour and the stone and woodwork will give those delightful half-tones at once the delight and despair of the artist. Then embowered in trees, the picture will be complete.

It is that picture we will endeavour to sketch; the picture of that village, which, though it lacks the subduing touch of time, is the delight of all who visit it and the pride of all who live in it. Need we say that the village in question is Port Sunlight?

Port Sunlight Schools form one of the prettiest blocks of buildings it has been our privilege to inspect. Built in the Tudor style of architecture and situated in the very heart of the village with open spaces on every side, they are highly picturesque from whichever point you view them. The internal arrangements of the schools do not belie the favourable impression created by their charming exterior. The woodwork throughout is in light oak and the schools are fitted with every possible convenience and appliance for the comfort of happy children.

Happy, indeed, they must be in these delightful schools; and happy indeed they appear to be, as in they march, in single file, from the playground, to the pianoforte accompaniment of one of the older children. It does one good to look upon their chubby, rosy, smiling faces.

Probably many of the children will, in years to come, be scattered over the face of the Earth. With what feelings of pleasurable regret for days that are past will they look back upon a childhood spent under such cheering influences, amid such lovely surroundings, in the sunny village so aptly termed Port Sunlight.

The writer of this postcard, sent to a Miss Forester in Glasgow, advises the recipient:

This is a paradise for school children and school teachers. Get a place here and don't mind heaven.

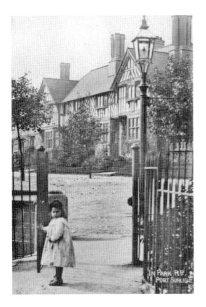

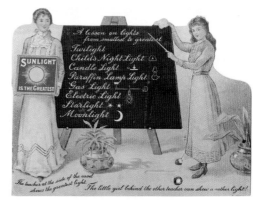

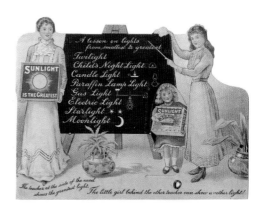

Above: Postcard. Paradise for schoolchildren.

Above right: Victorian scrap. A teacher with vision.

Below right: Victorian scrap. A little girl who listens.

The delightful Victorian scrap on the preceding page has a little lever attached to the back (not shown). The top picture does not show the little girl standing behind the teacher but when the lever is pulled, she is revealed. The verse on the back of this scrap reads:

There's one golden rule
We all learn at school,
To keep ourselves neat and bright. We hope
We shall take our places,
With clean hands and faces,
And our clothes washed with SUNLIGHT SOAP.

On 22 June 1911, King George V was crowned at Westminster Abbey, and his wife was crowned as Queen Mary. Children from Port Sunlight gathered at the Bandstand to celebrate the occasion. The Bandstand no longer exists; it was dismantled in the 1930s. At 1.40 p.m., the exact moment of King George V's coronation, the clock at the Royal Liver Building in Liverpool, a short distance away from Port Sunlight, was set into motion.

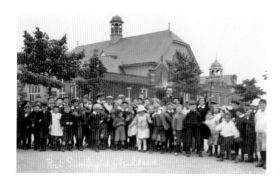

Postcard. Children outside Church Drive School.

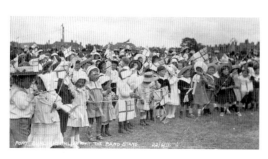

Postcard. Coronation celebrations.

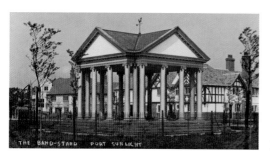

Postcard. The Bandstand.

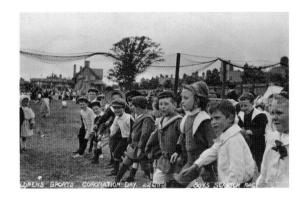

Postcard. Boys on Coronation day.

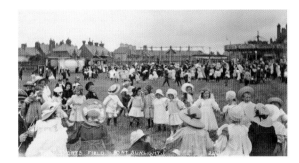

Postcard. Coronation
celebrations continue.

Victorian scrap. The prize winners.

The verse printed on the reverse of this scrap is entitled *The Prize Winners* and reads:

'Hurrah!'
shout the children, joyous and gay
They have been to the fete
and won the day.
And sweet are their smiles,
bright are their eyes
For Sunlight Soap
they have gained as their prize.

Who was Little Jennie?

The following story, reported in the *Liverpool Daily Post* on Saturday 20 February 1915, has haunted me from the day I first read it. I suspect we will never know if this extraordinary sailor ever wrote the second letter.

Sailor and the Child

Some weeks ago a little girl who attends the Port Sunlight schools sent a pair of warm cuffs to the sailors and it would seem that the useful gift, together with her child-like note, came into the hands of a seaman on HMS *Yarmouth*. In a touching letter, the recipient sends his gratitude to his unknown friend:

'I was so surprised to receive the letter and cuffs that you sent me. It is nice to think that someone who we know nothing about is thinking of us while we are scouring the angry seas … we shall all be glad when the war is over but the German fleet seems as if they will never meet us. I cannot write much but I was determined to get a few minutes in which to thank you for the cuffs.

You must keep this letter in memory of the sailor who is wearing your cuffs.

They are very useful as we get some bitter cold nights at sea. Now, little Jennie, we are sure of winning this war and afterwards I shall write to you about it, if I am alive.'

Victorian scrap. A sailor with warm heart and hands.

Boy Killed at Port Sunlight

You won't find the name Master John William Sowerby in the history books but you read it here because I would like to record the story of a young man who sleeps today, in death, in the open air as Lord Leverhulme, resting a few steps away, did in life.[1]

I found Master Sowerby's gravestone by chance and was intrigued by the inscription:

'John William Sowerby, only son of J. J. and E. Sowerby of New Brighton who was accidentally killed at the works of Messrs Lever Bros Ltd. 14th July 1915 aged 15 years.'

The archives at Unilever do not reveal details about the incident, but they hold a record of date of death. I failed to find any online newspaper reports about the tragedy but Mr Will Meredith from Wirral Archive Services found this report from the *Birkenhead News*, dated Saturday 17 July 1915:

Boy Killed at Port Sunlight

The West Cheshire Coroner Mr J. (C.) Bate held an inquest at New Ferry (last) Thursday into the circumstances attending the death of a lift boy, named Willie Sowerby, only son of John Sowerby and grandson of Mr John Sowerby, late of Merseyside.

From the evidence it appeared that the lift in which the lad was working got jammed.

The jury returned a verdict of 'accidental death'.

The newspaper is too torn and fragile to scan. On the same day as receiving this information, I received a copy of the young Master Sowerby's death certificate in the post. It confirms date of death as 14 July 1915 in the cottage hospital.[2] Cause of death: 'Injuries received the same day through being crushed by a lift in the works of Messrs Lever Bros – Accidental.'

If you wish to visit the grave, walk through the lychgate at Christ Church in Port Sunlight, turn immediately left, taking the path nearest the railings close to the road. Walk twelve to fourteen paces. The grave (pictured) is on the right-hand side.

Summertime sees Master Sowerby's resting place warmed by the sun's rays and in winter, when snow falls, he is sheltered by a white counterpane, which protects him from winter's chill.

RIP Master Sowerby. (Photo Tom Hughes)

11

Artists

Lord Leverhulme had quite a connection with artists, one way or another. The most famous story associated with him is, perhaps, the portrait of him by Augustus John.

Leverhulme arranged for a three-quarters length portrait of himself to be painted by John, which was duly completed.

After Lord Leverhulme had seen the finished work he wrote to John asking that it be delivered to the house he owned in Rivington, Lancashire – 'The Bungalow'.

He had no intention of hanging the portrait in The Bungalow, or anywhere else for that matter, because he was not pleased with it. To ensure that no one saw it, he intended putting it away in his safe. The story is recalled by Lord Leverhulme's son:

> When he opened the safe, however, he realised that it was split into partitions, and any idea of rolling up the entire canvas and placing it inside was out of the question and so, acting on the impulse of the moment, he cut a square, including the head, out of the picture and placed it in the safe.

The rest of the picture was left in the packing case in a corner of the room and the housekeeper, noting that the case was marked 'returnable', had it nailed up and sent off. On opening it, Augustus John was, not unnaturally, more than surprised, and on 30 September he wrote for an explanation, saying that he proposed to give the matter the widest publicity. On 4 October Leverhulme answered the letter and expressed distress at the unfortunate blunder which had occurred, at the same time describing, with perfect frankness, what had happened. Augustus John replied that he was glad to know that Leverhulme had no intention of vexing him but pointed out that it was very annoying to an artist to have his work destroyed.

The incident was publicised at the time and it remains one of the more 'famous' events concerning portraits, but there is another story relating to an artist that is less well known, although it, too, was reported in the press at the time.

The following article was printed on Thursday 22 September 1921 by the *Yorkshire Post and Leeds Intelligencer*:

> Lord Leverhulme is once more in artistic hot water. This time it is not Augustus John and the decapitated portrait; it concerns Sir William Orpen and a portrait of Lord Leverhulme in mayoral robes which was to be hung in the Town Hall of Bolton.
>
> The order for this presentation portrait was entrusted to Sir William Orpen. At the preliminary conference Lord Leverhulme desired that his portrait in mayoral robes should be a full length one, standing. Sir William suggested that a much finer effect would be obtained if he depicted Lord Leverhulme as sitting. The artist's idea was carried out and the finished work dispatched to Bolton.
>
> Then a difficulty arose as to the price. Lord Leverhulme's case was that he arranged for a full length portrait at 3,000 guineas and because he has been painted sitting he maintains that it is but the equivalent of a half-length portrait, and that, therefore, it should be paid for accordingly – with 1,500 guineas.

Sir William, who is at present making one of his periodical visits to Paris, does not agree.

Interviewed by Mr Donohoe, the *Daily Chronicle's* correspondent in Paris, Sir William Orpen, said: 'I hate making any statement and, above all, I don't wish to be dragged into a controversy with Lord Leverhulme, for whom I entertain the highest feelings of respect and admiration. It is perfectly true that for artistic reasons I suggested to Lord Leverhulme that a finer artistic effect would be obtained if I painted him sitting instead of standing. He consented and it puzzles me now why he should get it into his head that because of this I should be paid at half the price agreed to.

'The portrait of Lord Leverhulme is a very big canvas, and, to say nothing of my artistic labours, there is just as much paint and varnish used in it as if he had been standing and not sitting. Lord Leverhulme, I must say, has behaved throughout in a very charming way. When I declined to accept his reduced price, he wrote me a very kindly letter reiterating his offer of 1,500 guineas and, hoping that, despite the misunderstanding, we should always remain warm friends. He suggested that if I still found his offer unacceptable the matter should be referred to arbitration. He indicated Sir David Murray, who is a common friend, as arbitrator. I am perfectly willing to accept Sir David Murray's arbitration and to abide by his decision. But I have told Lord Leverhulme that I am content to leave it to his own conscience whether he should pay me half rate or full rate.'

According to Leverhulme's son, Sir David Murray was loath to undertake so delicate a task in the glare of so much publicity. The question of price was, in the end, settled amicably between artist and sitter.

Modern-Day Artists

An appreciation of the architecture in Port Sunlight has always encouraged artists to paint its buildings.

I am lucky to own the original artwork of two modern-day artists. Would you like to see them?

First, *The Lady Lever Art Gallery*, painted by Gordon Wilkinson, whose work is often featured in the magazines *Cheshire Life* and *Lancashire Life*.

Artist Gordon Wilkinson. (Photo Tom Hughes)

The second painting, *Cottages*, is another Gordon Wilkinson delight. The detail in his paintings is extraordinary. I always look forward to sharing a cup of tea with Gordon and his lovely wife Val.

Artist Gordon Wilkinson. (Photo Tom Hughes)

The following picture, *Bridge Cottage*, was painted by Stuart Irwin, a Wirral-born artist. This house was occupied by Lord Leverhulme while Thornton Manor was undergoing renovation. Its interior was featured in the film *Chariots of* Fire and it is today used by the residents as a 'community hub'. Many interests are covered, including tea and coffee mornings, business networking, a book club, painting, sewing, knitting, Indian head massage and computer workshops. The villagers could not ask for more.

Would Lord Leverhulme approve of this use for his old home? You bet he would.

The fourth and final painting is one of Stuart Irwin's, depicting the Old Post Office (now a tea room). I love the way he handles trees and clouds.

Stuart and I have often sat at my kitchen table, discussing Lord Leverhulme and his legacy. We know there must be many treasures relating to the Port Sunlight story out there still, waiting to be found. A letter hiding in a forgotten corner of a drawer, a postcard sitting on a stall at a summer fete or sharing cobwebs with spiders in an attic…

Artist Stuart Irwin. (Photo Tom Hughes)

Artist Stuart Irwin (Photo Tom Hughes)

12

Weddings and Washing

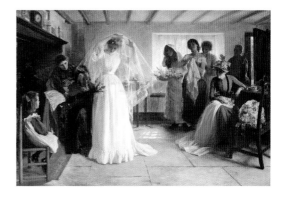

The Wedding Morning © National
Museums Liverpool.

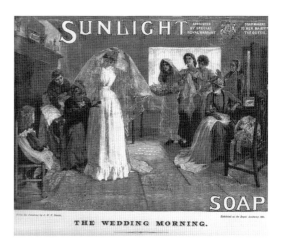

Lord Leverhulme's interpretation.

This painting, *The Wedding Morning* by John Henry Frederick Bacon, hangs in the Lady Lever
Art Gallery, Port Sunlight.

Lord Leverhulme bought the picture from a Royal Academy private view in 1892 to use
specifically as an advertisement for Sunlight Soap.

In the original painting there is a clock on the mantelpiece and a cup and saucer on a table,
upon which an onlooker's arm is resting. Sunlight Soap replaces the clock and cup and saucer in
the advertisement.

Lord Leverhulme's Joke about Weddings

John Dory Weds An-Chovy

Speaking at the Nation's Food Exhibition, Olympia, just after his 71st birthday, Lord Leverhulme asked:

'If fish were to marry, which would be the first? John Dory and An-Chovy. The bridegroom's present would be her-ring. They would spend the honeymoon in Wales and settle down in Fishtown. Instead of stairs their house would have 'a hoister' and when the wife called her husband in the morning she would say 'Stur-geon'. If he were cross she would call him crabby. They would keep as pets a dogfish and a catfish and wear on their feet soles and eels.'

Not long after I read this joke, which mentions herrings, I found the following photograph of the 3rd Viscount Leverhulme, Philip, presenting Prime Minister Margaret Thatcher with a gift of herring. Philip Leverhulme was Prime Warden of the Worshipful Company of Fishmongers. This ceremony took place in June 1984, six weeks after the return of major supplies of British caught herring after a seven-year absence.

If I may make another connection to the grocery trade here – Lord Digby Jones, who kindly supplied a quote for my book, is a grocer's son. I asked Lord Jones if I could quote something his father always said about business and he gave me permission to do so: 'The three most important things in business are customer, customer, customer.' Mr Lever would have agreed with him, of that I am sure.

Returning to Philip Leverhulme, he had a great passion for horse racing and a fellow lover of the sport, Queen Elizabeth the Queen Mother, often accompanied him to race meetings.

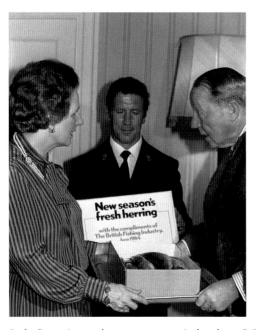

Left: Grocer's grandson meets grocer's daughter. © Press Association Ltd.

Right: Victorian scrap. A race with only one winner.

The 'Sunlight' Race

Over hedge and ditch you fly,
While the whip and spur you ply,
Striving not to be the last
When the winning post is passed

Light of hand and firm of seat,
Ponies that are strong and fleet
Outstretched neck and swinging stride,
That's the sort of race to ride!

Keep on trying all you know,
No white feather you must show,
Faint heart ne'er in any case
Won fair lady or a race

Struggle on, then, might and main,
SUNLIGHT SOAP'S the prize you'll gain,
And well the prize is worth the race,
For SUNLIGHT brightens every place.

Queen Elizabeth the Queen Mother would often stay at Thornton Manor, and at the time of writing couples who marry at this remarkable location can sleep in the room once occupied by her.

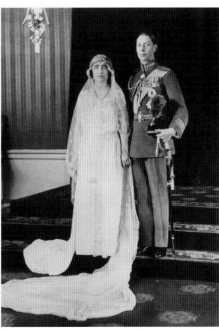

Left: Victorian scrap. Philip Leverhulme and HM the Queen Mother shared a love of horse racing.

Right: HM the Queen Mother on her wedding day.

From the Queen Mother may I take you to a Prince, or rather a ballad about 'Prince Sunlight'? [1]

A sweet little princess, one day all unwary,
Fell into the trap of a wicked old fairy.
By using a spindle and pricking her thumb;
You all know the story and what is to come –
How she slept for a century, when to assist her
To awaken, a charming prince came and kissed her.
He wanted to marry her then right away,
So the wedding was set a week from that day.
Now the queen was much worried concerning the trousseau,
And wanted the wedding postponed but to do so
The princess announced that she was not inclined
And without any question had made up her mind
To have her clothes washed of their hundred years' dustiness,
And thereby avoid the court dress-maker's crustiness.

So the princess' clothes, every stitch that she owned,
Were sent to the wash and the laundresses groaned.
There were sixty-five petticoats, fifty chemises,
And ninety-eight handkerchiefs, solely for sneezes;
With dozens all trimmed with embroidery and lace,
There were dresses and stockings and flannels – but space
Is too short to enumerate. Never, oh never
Were princess' garments so dirty. However,
The laundresses soaked them and soaped them and rubbed,
Then they blued them and bleached them and boiled them and scrubbed:
But the clothes would not whiten in spite of their trying.
The queen was indignant; the princess was crying
For fear that she'd have nothing ready to wear.
The king was disgustedly sniffing the air
Which was reeking with soap suds. The poor prince was smitten
With fear lest the princess should give him the mitten.

Victorian scrap. Washing ninety-eight handkerchiefs.

The king madly stamped his majestical heel
And roared to the prince, 'Now I, sir, you feel
That you've gotten the court in a horrible pickle,
Out of which you must help us or prove yourself fickle.
I give you three days, sir, to bring us relief,
If you cannot provide it you'll soon come to grief.'
Then swooned the sweet princess before her stern parent
The prince calmly bowed and dispatched on an errand
A courier mounted upon his own steed,
To bring from his realm at a steeple-chase speed,
The kingdom's chief prize, which had mysteries magical,
Able to keep things from proving too tragical.
One day had gone by, then the second and third,
And all were impatiently waiting some word,
When the prince who was watching cried: 'Man's only hope.
The caravan cometh! All hail 'Sunlight Soap'.'

The princess ecstatically fell on her knees,
But the huffy old monarch was ready to sneeze
At the simple enchantment. The prince led the way
To the laundry, triumphantly chanting this lay:

'Don't rub or scrub above your tub, but soap the clothes with greatest care,
Don't toil and moil or let them boil, but roll them tight and leave them there.
Then when you wash, just swish and rinse the clothes in water,
And by tonight they'll all be white, fit for a monarch's daughter.'

The laundresses thought that the prince must be joking,
But they soaped all the garments and left them in soaking
All tightly rolled up, for perhaps half an hour,
And when they were ready to boil and to scour,
They found it was useless – for rinsing and rubbing
Took all of the dirt out without any scrubbing,
And made them so quickly and perfectly white,
That the princess' trousseau was finished that night.
She was married next day amidst gladness and laughter,
And used 'Sunlight Soap' for her clothes ever after.

Victorian scrap. Laundress impressed with Sunlight soap.

13

Mr Lever's Accounts

I promised we would return to the account book that once belonged to Mr Lever, so let us open it one more time.

The year is 1890 and Mr Lever has carefully compiled his outgoings for the year. Port Sunlight has been a familiar name to many for two years and Mr Lever is now living in Thornton Manor. In his usual efficient style, he has broken down his expenses in the following way:

House
Rent/rates/coals, etc. (Mr and Mrs Lever rented Thornton Manor from the Forwood family at this time).
Wine, beer, tobacco
Clothes
Travelling, theatre, cabs

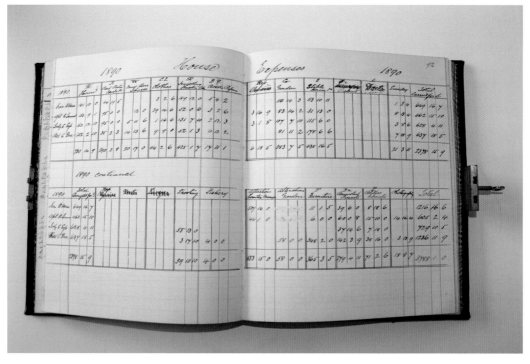

Account book. House expenses. (Photo Tom Hughes)

Books and papers
Repairs
Garden
Stable, horses, etc.
Lawyer
Doctor
Sundry
Shooting
Fishery
Alterations Thornton Manor
Alterations Garden
Furniture
Benevolent
Presents
Politics Liberals
Photography

I thought it might be worthwhile to put these in order of expenditure, so if you don't mind another list here it is with the highest spend first:

House	£730	14s	9d
Alterations Thornton Manor	£553	15s	0d
Stable, horses, etc.	£438	16s	5d
Travelling, theatre, cabs	£525	1s	7d
Garden	£383	7s	5d
Furniture	£365	3s	5d
Rent/rates/coals, etc.	£290	2s	8d
Benevolent/Presents	£279	4s	11d
Politics Liberals	£ 71	2s	6d
Shooting	£ 59	10s	10d
Alteration Garden	£ 58	0s	0d
Clothes	£ 44	2s	6d
Sundry	£ 21	3s	11d
Wine/beer/tobacco	£ 20	17s	0d
Photography	£ 18	8s	7d
Books and papers	£ 17	11s	1d
Repairs	£ 6	18s	5d
Fishery	£ 4	9s	0d

No entries were made this year for either doctor or lawyer. Note also how much Mr Lever spent on furniture and how little on clothes, amassing fine pieces of furniture in his lifetime. His grandson, Philip Lever, the 3rd Viscount Leverhulme, died in 2000. In 2001 Thornton Manor and its contents were sold. A Sotheby's spokesperson at the time said bids had been received from people living a quarter of a mile away and from folk living in the Middle East and the United States of America.

A 1604 James I walnut and inlaid chest sold for £350,000 while a twenty-four-seater dining table once used by Napoleon III sold for £322,500. The manor entered the record books after most of its contents were sold for over £9 million. How wise the young Mr Lever was spending £365 3s 5d on furniture in 1890.

There, I think, we must leave Mr Lever's account book and all that lies within.

Above left: Victorian scrap. Carpenter. (Entry in account book for alterations, Thornton Manor)

Above right: Victorian scrap. News vendor. (Entry in account book for books and papers)

Left: Victorian scrap. Photographer. (Entry in account book for photography)

Before we leave this chapter and go up to the roof of Thornton Manor, may I mention one of the servants who used to work for Lord and Lady Lever? Mr Lever's early accounts (*Chapter 1*) showed us how he furnished the bedroom and kitchen for his servants.

By the time Mr and Mrs Lever were living in Thornton Manor they had many more servants, one of whom was Miss Cecilia Dulston. She worked for Lady Elizabeth Lever, Lord Leverhulme's wife. Lady Lever's maiden name was Hulme. When raised to the peerage Sir William Lever (as he then was) adopted the name Hulme and became Lord Leverhulme.

I have a postcard addressed to Miss Dulston at Thornton Manor. Posted from New Ferry on 3 March 1905 it reads: 'I hope you and your mother are keeping well. B. Prodger.'

Posted from the village of Thornton Hough on 29 September 1908, another card was sent to Miss Dulston when she was working at Roynton Cottage, Rivington, one of the many properties owned by Lord Leverhulme: 'Dear C, I hope you are well. Have you got one like this? I hope not. W. L. Gertie.'

Roynton Cottage was destroyed in an arson attack by suffragette Edith Rigby in 1913. She regarded the attack as a protest against the government.

Leverhulme had been a Liberal Member of Parliament and he was a supporter of women's suffrage.

The messages on these cards are mundane, but because they are addressed to one of the servants and one of the cards is addressed to a building burned down by a suffragette, they are interesting.

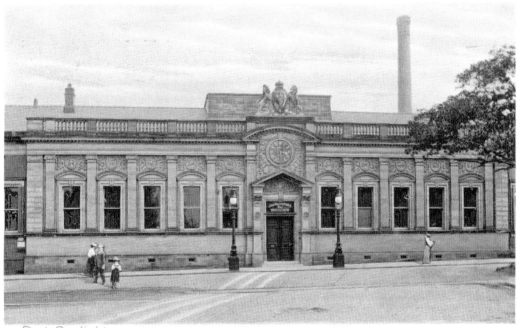

Port Sunlight. Main Entrance to Offices.

Postcard addressed to Miss Dulston at Thornton Manor.

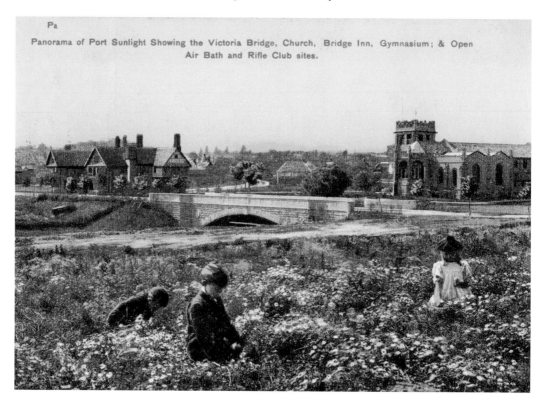

Postcard addressed to Miss Dulston at Roynton Cottage.

14

Sleeping with Swallows

Even the swallows trusted Lord Leverhulme. His son records in the book he wrote about his father that:

> From the year 1910, when the first pair of swallows nested in his newly constructed open-air bedroom at Thornton, he kept every summer a carefully written record of his observations, showing when the swallows arrived, when they built their nest, the number of eggs and when the young were hatched, when the fledglings first left the nest and when the birds finally migrated.

Victorian scrap. Swallows.

The first time I slept in the late Lord Leverhulme's open-air bedroom at Thornton Manor, with only distant stars for company, I realised why that space may have been so appealing to one of the greatest businessmen the world has ever known.

No opulence up here on the roof. No Old Masters sharing the walls with gilded lamps and ancient tapestries. No wallpaper either. No thickly lined curtains to keep the draught out for there are no windows.

No chandeliers. No Wedgwood, Coalport or Derby. No Chippendale, Hepplewhite or Sheraton.

No Persian carpets, no glowing log fires in grates, surrounded by magnificent marble fire surrounds.

No grandfather clocks ticking or chiming, reminding us what o'clock it is, no music, no voices.

Silence.

No interruptions.

Nothing to distract at all...

What better environment could there be for clear thinking and making sound business decisions?

When Lord Leverhulme descended the staircase from his bedroom early each morning into the beautiful home that was (and still is) Thornton Manor, his day had already begun.

His days were full – perhaps a visit to the USA and Canada, Switzerland, Africa, entertaining at home, sailing round the world, hosting staff dances at Thornton Manor, duties as a Liberal MP, acquisition of other businesses, purchasing islands in the Outer Hebrides, dining with the King and Queen...

A quiet, stark, open-air bedroom can be very inviting at the end of a busy day.

Perfect for sharing with swallows.

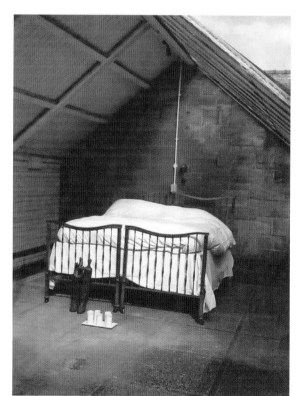

Above: View from Lord Leverhulme's bed.

Left: Lord Leverhulme's open-air bedroom.

15

Work and Play

A Grocer's Assistant with £10,000,000

The following story was printed in the *Wells Journal*, Friday 20 January 1931:

Dr MacLachlan, of Pinkacre, Coleford, gave a deeply interesting account of his experiences as a Medical Missionary on the West Coast of Africa to a good attendance of the local branch of the Church of England Men's Society. The lecture was punctuated with frequent outbursts of laughter and proved as mirth-provoking as it was instructive. At the close Dr MacLachlan was heartily thanked on the proposition of the Vicar. One story deserves repetition since it concerns Lord Leverhulme and will probably be new to most people. On the voyage out a dance was promoted and Lord Leverhulme, who was fond of dancing, attended. His Lordship, from a physical point of view, was not impressive, being well below average height and unusually stout. He approached a lady of the grand dame type and begged the honour of a dance. The lady, after a slight hesitation, graciously condescended. After the dance she asked her cavalier what business was taking him to the Gold Coast.

Foxtrot

Postcard. A reluctant partner.

'I am a grocer's assistant,' replied Lord Leverhulme who certainly could claim having been of considerable assistance to the grocery trade. Later he again approached the lady but this time he was indignantly refused and publicly snubbed. Next day, to her mortification, she learned that her would-be partner was none other than Lord Leverhulme, on his way to complete arrangements for forming the Niger Company with a capital of ten millions.

Mr and Mrs Lever Entertain at Home

The *Cheshire Observer* reported the following in their newspaper issued on Saturday 10 November 1900:

> Mr and Mrs W. H. Lever have this week entertained at an 'At Home' at their residence, Thornton Manor, Thornton Hough, nearly 1,000 ladies and gentlemen who worked on Mr Lever's behalf at the last election.

I have an original invitation in my possession, reproduced below.

Mr Lever had stood as Liberal candidate for Birkenhead but was defeated by Joseph Hoult.

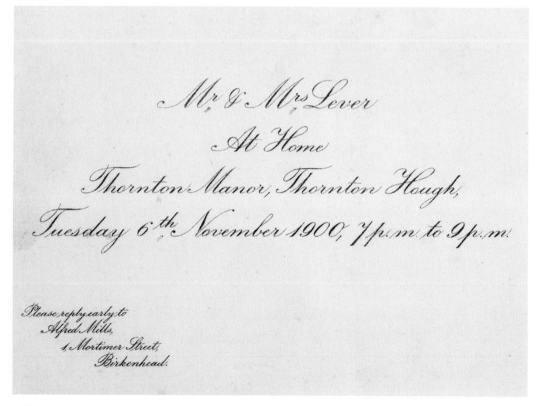

Invitation from Mr and Mrs Lever.

Victorian scrap. Sharing a nursery
rhyme with dolly.

If there was ever a house made for entertaining, Thornton Manor fits the bill entirely. Lord
Leverhulme loved entertaining (*see programme dated 1 January 1903*) and written on the back of
the Victorian scrap above, in bold type, is: 'There's music in the home where SUNLIGHT SOAP
is used.' This is in addition to the following verse:

> There's a nursery rhyme which tells
> of a horse
> And a lady who rides it to Banbury
> Cross,
> And the reason there's music wherever
> she goes
> Is not solely, as you may have been led
> to suppose,
> Because of the rings and the bells on
> her toes,
> But because she's used SUNLIGHT
> for washing her clothes.

Lord Leverhulme had a great appreciation of art, amassing a great collection in his lifetime.

The barrel-vaulted ceiling in the Music Room at Thornton Manor contains painted panels by
Giovanni Cipriani. The painted panels in the Gold State Coach used at the coronations of every
British monarch since George IV were also painted by him.

Lord Leverhulme also loved music and dance and today the Music Room is still used for this
purpose. Lord Leverhulme continues to watch over proceedings, for a large portrait of him hangs on
a wall in that room, and whenever I see it I feel he is waiting there, ready to continue where he left off.

Cover of
programme.
Thornton
Manor.

Programme
of music.

Dance programme with space to write engagements.

Lord Leverhulme's Long Day

This rather charming report was issued in the *Tamworth Herald* on Saturday 30 September 1922:

> Lord Leverhulme, who was 71 on Tuesday, still believes in leaving a comfortable bed at 4.30 in the morning. To a press representative, who found him working as hard as ever at the office of Lever Brothers in Blackfriars, London, he said that he attributed his good health to regular habits and taking pleasure in his work.

He gave these details of his ordinary day:

4.30 am – Rise and spend 20 min. in gymnastic exercises.
5.00 – A cup of tea. Read business reports and make notes for correspondence.
7.30 – Breakfast of toast, butter, marmalade and tea.
7.50 – Read the newspapers.
8.00 – Reply to letters.
8.30 – Motor to Blackfriars office.
9.00 – Work.

1 pm – Lunch in office of cold meat or two poached eggs, cup of tea.

1.15 – Sign letters.

1.30 – Short sleep.

2.15 – Work.

5.30 – Motor home to Hampstead.

7.30 – Dinner.

10.00 – Bed, if possible.

Lord Leverhulme added that he has never smoked[1] and he drinks alcohol only on special occasions. His only outdoor exercise is walking.

He spends the evening in social pleasures or a visit to the theatre and makes it a rule never to discuss business after leaving the office.

I have always marvelled (and I know others have too) at how Lord Leverhulme found time to achieve all he did. Perhaps this gives us a little insight into how he fitted so much into his day – meticulous planning, almost to the second.

Whether in Port Sunlight, London or countless other places, Lord Leverhulme always had plans to meet other people, as the letters on pages 81 and 82 show. The following letters are addressed to Clarence Barron, president of Dow Jones and manager of the *Wall Street Journal*.

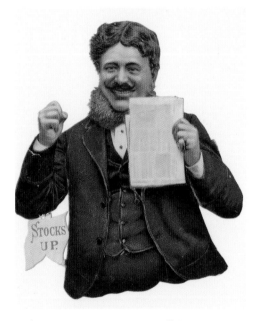
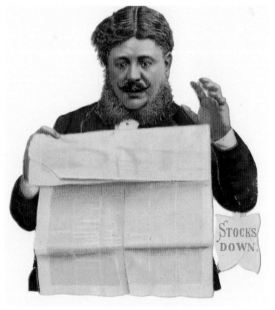

Left: Victorian scrap. Joy on Wall Street.

Right: Victorian scrap. Sorrow on Wall Street.

M/S

PORT SUNLIGHT,

CHESHIRE,

April 29th, 1921

Clarence W. Barron, Esq.,
 Carlton Hotel,
 London, S.W.1.

Dear Mr. Barron,

I see from a paper I have received that you are in England and staying at the Carlton Hotel. I hope to be in London the beginning of next week, and should be very glad to see you.

I shall be at my London office, 33 St. James's Square, S.W.1, Monday, Tuesday and Wednesday mornings of next week, or I could call to see you at the Carlton Hotel if you would let me know what times you would be in.

Hoping you had a comfortable voyage and with all good wishes,

Yours sincerely,

Leverhulme

Lord Leverhulme writes to Clarence Barron.

THE HILL.

HAMPSTEAD HEATH,
NORTH END,

LONDON N.W. 3.

3rd May, 1921.

Clarence Barron, Esq.,
 Carlton Hotel,
 Pall Mall, S.W.1.

Dear Mr. Barron,

 I do not know whether you have seen the article
by Chesterton on America. I quite agree with the views
of Mr. Chesterton.

 It was a great pleasure to myself and Mr. McDowell
to meet you last night. Our only regret was that the ladies
of your party could not accompany you.

 With all good wishes,

 Yours sincerely,

A-11068

Another letter from Lord Leverhulme to Clarence Barron.

I do not possess a photograph of Lord Leverhulme travelling to his Blackfriars office, or motoring home to Hampstead, but I do have this photograph of a young (unknown) man driving in a Sunlight Soap box. Something tells me Lord Leverhulme would approve.

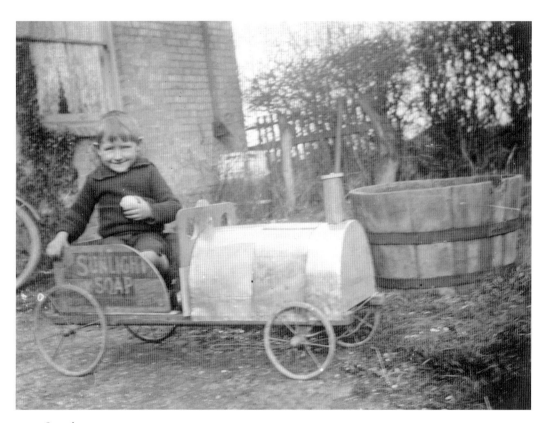

Soap box motor.

The letter on page 84 is an example of one of Lord Leverhulme's replies to one of the many letters he had to consider during his working day:

I thought it worth mentioning a little about the *Iolaire*, as I was unfamiliar with its story, and when I read the jury's verdict, which included the fact that there were insufficient lifebelts and boats almost seven years after the *Titanic* disaster, I wanted to read more.[2]

Additionally, 2019, which is just around the corner, will see the 100th anniversary of this tragedy.

Once described as the blackest day in the history of the Western Isles, the *Iolaire* sank in sight of Stornoway Harbour on New Year's Day, 1919. More than 200 servicemen from the Isle of Lewis and Harris, returning from the First World War, died.

The King and Queen sent a message of sympathy, and so did Lord Leverhulme, who had purchased the Island of Lewis the year before. He also led calls for a disaster fund to be set up.

The jury, after an absence of over an hour, returned a unanimous verdict, finding:

That the *Iolaire* went ashore and was wrecked on the rocks inside the Beasts of Holm about 1.55 in the morning of 1 January 1919, resulting in the death of 205 men;

R/H.

♛

THE HILL,
HAMPSTEAD HEATH,
NORTH END.
LONDON N.W. 3.

18th March.1919.

R.P.Read Esq.,
 19 Canning Place,
 Cathedral Street,
 Glasgow.

Dear Mr.Read,

.. I am obliged for yours of the 14th.,and I am delighted
to hear of the success of your Concert,and the handsome contribution
you have been able to contribute to the "Iolaire" Disaster Fund.

With hearty congratulations and thanks.

Yours sincerely,

Leverhulme

Lord Leverhulme

The *Iolaire*.

That the officer in charge did not exercise sufficient prudence in approaching the harbour;

That the boat did not slow down and that a look-out was not on duty at the time of the accident;

That the number of lifebelts, boats and rafts was insufficient for the number of people carried;

That no orders were given by the officers with a view to saving life and further;

And that there was a loss of valuable time between the signals of distress and the arrival of the life-saving apparatus in the vicinity of the wreck.

They recommended:

1 That drastic improvements should be made immediately for conveying the life-saving apparatus in the case of ships in distress;

2 That the Lighthouse Commissioners take into consideration the question of putting up a light on the Holm side of the harbour and;

3 That the government will in future provide adequate and safe travelling facilities for naval ratings and soldiers.

The jury desired to add that they were satisfied that no one onboard was under the influence of intoxicating liquor and that there was no panic on board after the vessel struck.

As a rider to their verdict they recommended to the Carnegie Trust and the Royal Humane Society Seaman J. F. Macleod for some token of appreciation of his conduct in swimming ashore with a line, by means of which the hawser was brought ashore and many lives were saved.

The jury also extended their sincerest sympathy to those who had lost relatives in this regrettable disaster. They also expressed their appreciation of the hospitality shown to the survivors by Mr and Mrs Anderson Young of Stoneyfield Farm.

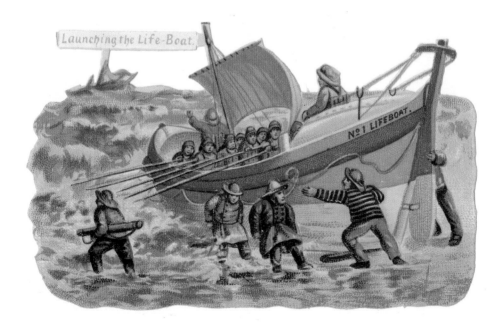

Victorian scrap. Lifeboat to the rescue.

16

From Lifeboats to Lifebuoy

In 1926 Lever Brothers launched a 'Clean Hands' campaign. It encouraged children to wash their hands 'before breakfast, before dinner and after school'.

Travelling in the Gambia some time ago I met a group of families all washing their hands with Lifebuoy soap. The children you see with me in the photograph below had just washed their hands thus.

As they shook my hand, including the dear little soul in my arms, they proudly announced they had killed all the worms.

I think they meant germs.

The author in Gambia.

17

Manners Maketh Man

An old saying and how true the sentiment.

The following letters (and an email!) are illustrations of how busy, prominent people can find time to be courteous. They also remind me of another saying – if you want something done, ask a busy person.

The replies you read here are all in response to requests for autographs.

Date: Friday, 7 March 2014, 15:46

Dear Jo

Many thanks for your interesting letter of 5th March, to which I have responded in the traditional way. However, in the meantime I thought I would add my "e-autograph" to your collection.

With warm regards

Paul

Unilever

Paul Polman, Chief Executive

Unilever, 100 Victoria Embankment, Blackfriars, London, EC4Y 0DY

T: +44 20 7822 5874

Unilever PLC, Registered in England & Wales, Company No 41424, Registered Office: Port Sunlight, Wirral, Merseyside, CH62 4ZD

www.unilever.com | www.facebook.com/unilever

Email from Paul Polman.

Unilever House
100 Victoria Embankment
Blackfriars
London
EC4Y 0DY

T: + 44 20 7822 5874

Paul Polman
Chief Executive Officer

7th March 2014

Dear Jo

Many thanks for your interesting letter of 5th March – and I have much pleasure in appending my autograph below, as requested.

With warm regards,

Unilever PLC
Registered in England & Wales
Number 41424
Registered office Port Sunlight
Wirral, Merseyside CH62 4ZD

Unilever NV
Registered in Rotterdam
Commercial Register No 24051830
VAT No NL004966466877

Paul Polman's autograph.

E/H.

THE HILL,
HAMPSTEAD HEATH,
NORTH END,
LONDON N.W.3.

Telegrams.
LEVERHULME
HAMPSTEAD HEATH.
Telephone.
HAMPSTEAD 1324.

22nd June, 1921.

George H. Grubb Esq.,
24, Bedford Street,
Strand, W.C.2.

Dear Sir,

I am obliged for your letter of the 21st inst.
and have pleasure in enclosing copy of my autograph herewith.

With all good wishes,

Yours sincerely,

Lord Leverhulme's autograph.

An autograph from Samuel Smiles.

It took me a while to work out the word 'extent' in the letter Samuel Smiles wrote so, in case any other words are not clear, I include my interpretation of the whole letter:

Dear Sir,

As you say you admire my work, and admire me, I cannot refuse my autograph, and I hope it will, to a certain extent, enrich your collection.

Dear Sir, Believe me,

Yours most faithfully

Samuel Smiles LLD

The following quote reads as such:

If we take just a minute and look around us, we all have someone whose life we can improve, whose talent we can maximise, whose self-belief we can increase by what we do, not by what we say alone. Now that is leadership.

Was this a quote from Lord Leverhulme? Was it Samuel Smiles, perhaps, or Paul Polman? No. Although I can imagine any one of these saying this, it is a quote by Lord Digby Jones in his book *Fixing Britain*.

I asked Lord Jones if I could include a quote from his father, as referred to in Chapter 12. He readily agreed and, without me asking, additionally provided a quote for my book. Will you allow me to include him in this chapter?

18

Lord Leverhulme Accurately Predicts the Future

I recently visited a supermarket and placed a few items into my shopping basket. Nearing the checkout, I was approached by a young lady who asked if I was happy with my electricity and gas supplier. If I had wanted, along with my groceries, I could have signed up for electricity and gas to be supplied by this grocer.

Some days later, looking at documents for research, I found this article from the *Yorkshire Post and Leeds Intelligencer*. The piece was written by the newspaper's London correspondent and is entitled 'Grocer's Shop of the Future':

The grocer's shop is the cupboard, pantry and larder of the nation,' said Lord Leverhulme in opening the 28th International Exhibition and market of the trade at the Agricultural Hall, London, on Saturday. 'I am very proud to call myself a grocer, because,' he added jocularly, 'I was a grocer for nearly twenty years before I began my downward career as a soapmaker.'

Though Lord Leverhulme is 73, he is a man of high spirits and great vitality. This week he leaves for a long tour in West Africa and the Congo, and will be away for about six months, but before going away he was glad, he said, of this chance of talking to his old friends the grocers.

'There has been an immense advance in the trade since I began as my father's apprentice fifty-seven years ago,' he continued. 'But, so far as I can see, the principles of the trade are just the same.

'Success can only be got by loyal service to the public – not mere politeness but sincerity towards customers in considering their interests, wants and resources. It isn't enough nowadays merely to sell goods across the counter; a grocer must expand his knowledge and use his brains so as to improve the organisation and advance the development of the business. The great question in the trade today is still as it was in my young days, 'What is a reasonable profit?' Well, a man's profits in any trade are just what he is entitled to.

'There are differences in grocers, just as there are in lawyers. One barrister may get a fee of only a guinea, another must have a 10,000 guinea brief and others command briefs marked up to 20,000 guineas. They get those sums because they are entitled to them by the merit of their service. So with the grocer. The man who confines his efforts to handing stuff over the counter is only the equal of the one-guinea barrister.

'Referring to the tremendous developments in the grocery trade in his own lifetime, Lord Leverhulme predicted that a century hence nearly everything will be sold at the grocers. 'I can even imagine a small boy coming in and asking for a quart of electricity.'

'What for – heat, power or light?' the grocer will ask. 'Oh,' the boy will say, 'mother wants to drive the mangle.'

The article was dated Monday 22 September 1924.

19

A Call for Mr Danny Boyle

What is it about Bolton and its surrounding area? Why has it produced so many strong, successful people? I call them 'Bolton Wonders'. We have Lord Leverhulme, one of the most successful businessmen who ever lived. There are also Sir Arthur Rostron who gallantly went to the aid of *Titanic*, steeplejack Fred Dibnah MBE and Danny Boyle – who can forget the opening of the Olympics in 2012, where Mr Boyle perfectly captured the Industrial Revolution for us all?

Sorting through Victorian scraps one day I discovered this – I didn't know I had it as it came in a 'job lot'. Have you noticed the name on the newspaper?

The Port Sunlight story has been told many times since its creation in 1888, but in some ways it has not been told at all.

I don't expect Mr Boyle will pick this book up, but a friend of a friend might so – Mr Boyle, if you are looking for your next project, I have an idea for you…

Victorian scrap. Boyle makes the front page.

20

The Final Word

CHINA
Little John Chinaman slop, slop, slopped
His wash-day once meant sorrow but now all that is stopped.
Since SUNLIGHT SOAP has found its way
to China's wave-washed shore,
Little John's washing is a pleasure evermore.

In Chapter 3 we saw how Lord Leverhulme was held in high regard by Andrew Knox.

Now it is the turn of Mr Angus Watson, a travelling salesman at Lever Brothers who left the company to found his own business in canned fish. On hearing Lord Leverhulme had died, he commented:

> I cannot believe that the Chief has really gone; that the hero who meant so much to me when a boy, and played so large a part in my life ever since, has really been taken from us. I owe so much to him by way of example, inspiration and encouragement that life can never be quite the same again.[1]

We are now almost at the end of this story, and as we approach the final words I must tell you they are not mine or Lord Leverhulme's.

They were recalled by Angus Watson in his book *My Life*, and were uttered by a Chinese manservant in Vancouver who, in the early 1900s, was helping in preparations for a dinner at which Lord Leverhulme was to give an address.

The manservant, whose name was Ah Sin, was vigorously polishing the brasswork on the outside of the house where the dinner was to be held.

'Why are you working so hard?' a neighbour asked. 'They will all be frozen again tomorrow, Ah Sin.'

'Yes,' the Chinaman replied, 'but God is coming here to dinner tonight.'

Notes

A Special Acknowledgement

1. See Chapter 14.

Before Port Sunlight

1. For a full description, including the exterior of house, see historicengland.org.uk, list entry No. 1384539.

Stinking Soap

1. Regrettably, I cannot credit the author of this fine piece. Their name does not appear in the newspaper report.
2. 'Everybody has heard of the great Heidelberg Tun, and most people have seen it, no doubt. It is a wine-cask as big as a cottage, and some traditions say it holds eighteen hundred thousand bottles, and other traditions say it holds eighteen hundred million barrels. I think it likely that one of these statements is a mistake, and the other is a lie. However, the mere matter of capacity is a thing of no sort of consequence, since the cask is empty, and indeed always has been empty, history says. An empty cask the size of a cathedral could excite but little emotion in me. I do not see any wisdom in building a monster cask to hoard up emptiness in when you can get a better quality, outside, any day, free of expense.' Mark Twain, *A Tramp Abroad* (London: Chatto & Windus, 1880).

Global Advertising

1. Knox, Andrew M, *Coming Clean* (London: Heinemann, 1976).

Lord Leverhulme Speaks

1. This article appeared in the *Portsmouth Evening News* on Friday 8 May 1925.
2. Mawson, Thomas H., *The Life & Work of an English Landscape Architect: An Autobiography* (London: The Richards Press Ltd, 1927).

Lord Leverhulme and Samuel Smiles

1. Two further quotations about time, if I may: 'You may delay, but time will not' and 'Lost time is never found again'. Both are attributed to Benjamin Franklin, whose father, Josiah, was a candlemaker – and soapmaker.

Villagers Speak

1. On the date on which this postcard was written, 28 July 1914, Austria declared war on Serbia. One week later, Great Britain and Germany would be at war.
2. The Diamond – a central open area in Port Sunlight, approximately 40 metres wide and 350 metres long. A more detailed description can be found at historicengland.org.uk, list entry No. 1001637.

RMS *Titanic*

1. Vinolia soap was invented, manufactured, registered and patented by Blondeau et Cie, Vinolia Soapworks, London. Blondeau et Cie was founded by Dr Eggleston Burrows and Mr James Hill Hartridge.

Christmas and Winter in Port Sunlight and Beyond

1. A Christmas card sent by Sir William and Lady Lever from Leverville (today known as Lusanga), Belgian Congo. William Lever had travelled to the Belgian Congo to establish palm oil plantations.

Children and Schools in Port Sunlight

1. Lord Leverhulme preferred to sleep in the open air – that is to say, a space with no ceiling, no roof. If he could incorporate such a bedroom in the properties he acquired, he did so.
2. The Cottage Hospital still stands today, but as a hotel, and as such has guests rather than patients.

Weddings and Washing

1. Author unknown. Poem entitled 'The Ballad of Prince Sunlight'. Extract from Lever Brothers leaflet, undated but believed to be late 1800s.

Work and Play

1. Lord Leverhulme's son remembered differently. In his book *Viscount Leverhulme By His Son* he recalls, when speaking of his father: 'Until he gave up smoking he enjoyed a cigar and smoked two or three a day. He indulged in cigarettes very occasionally and hardly ever in a pipe. His decision to give up smoking was made on the 23rd of July 1896, at the house of a friend, Mr Robert Smith, of Liverpool, where he was spending the night…

On this particular evening in Liverpool the two friends had been discussing the question of smoking and whether it was possible to give up the habit. 'I will give it up if you will,' one said to the other. 'All right,' was the reply. It was a wager in which the satisfaction of winning was to be the only stake and from that day onwards, neither of them ever smoked. Attempts were made by friends to persuade them to consider the contest at an end and matches were struck with the suggestion that they should light a cigar simultaneously, but neither would give way.'

2. I hadn't realised it had taken so long for prescribed numbers of lifeboats to be enforced after the *Titanic* disaster. The first version of SOLAS (Safety of Life at Sea) was passed in 1914 in response to the tragedy, but it was not implemented immediately due to the outbreak of the First World War.

The Final Word

1. Watson, Angus, *My Life* (London: Ivor Nicholson & Watson Limited, 1937).